IMAGES
of America

HOUSTON
HEIGHTS

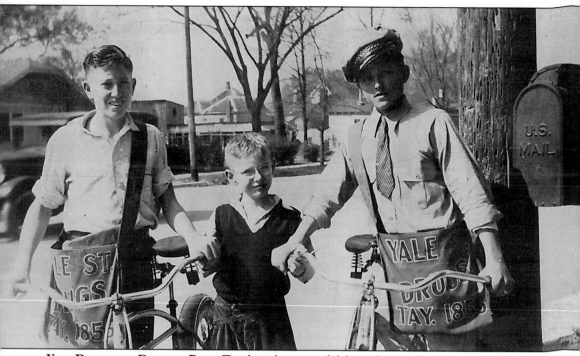

YALE DRUGSTORE DELIVERY BOYS. Two bicycle-powered delivery boys with their canvas shoulder bags are shown with Joe Dupuis, the owners' son, who would in later years run the pharmacy. (Courtesy of Joe Dupuis.)

ON THE COVER: Located at Twenty-second Avenue and Yale Street, this up-to-date air-conditioned drugstore featured Banquet ice cream, which was made on-site. Owned and operated by pharmacists Abel and Mildred Dupuis, their "drive up" service was one of the features that made the store a popular destination. An employee would come to the curb and take the order, whether for a banana split or a bottle of aspirin. (Courtesy of Joe Dupuis.)

IMAGES
of America

HOUSTON
HEIGHTS

Anne Sloan and
the Houston Heights Association

ARCADIA
PUBLISHING

Published by Arcadia Publishing
Charleston, South Carolina

Printed in the United States of America

Library of Congress Control Number: 2009922898

For all general information contact Arcadia Publishing at:
Telephone 843-853-2070
Fax 843-853-0044
E-mail sales@arcadiapublishing.com
For customer service and orders:
Toll-Free 1-888-313-2665

Visit us on the Internet at www.arcadiapublishing.com

CONTENTS

ACKNOWLEDGMENTS

My wholehearted thanks go to local historian Randy Pace, who so generously shared his collection of photographs, his research, and his architectural knowledge. His help was invaluable. In compiling the images for this book, I was also fortunate to be able to use photographs from the families of several early Houston Heights residents: Fred Whitty, Betty Wyatt Henriksen, Talbot Cooley, Nancy Sue Bammel, and Becky Brezik had collections of unpublished photographs that provided wonderful additions. Searching for photographs, facts, and memories of the past is similar to detective work, as I knew from writing two historical mystery novels about Houston Heights. With the help of super sleuths Sandra Wilson and Sherry Schauer Davis, I was able to find many people who were willing to share their photographs, anecdotes, and knowledge. I thank them for their participation. I also thank Lauriel Hindman for her invaluable assistance with a myriad of chores and Amy Lawson for unfailing good humor, legwork, and support. Patricia Brison and Tom Wilson both helped with editing and proofreading. Arcadia Publishing's acquisition editor Allison Yoder, a Heights resident, was incredibly helpful. Davis Hardware generously took apart and reframed donors' photographs. Only a small portion of Houston Heights' history is represented here. Every house and person has its own story, and the photographs of each are there waiting to be found.

Until after 1925, Heights Boulevard was always referred to as "Boulevard" in the Houston City Directory and the local newspapers, and Heights High School, in school songs and local slang, was known as "Heights High." Abbreviations for sources cited are Houston Heights Association (HHA) and Houston Metropolitan Research Center (HMRC). Other abbreviations include City of Houston Landmark (LM) and National Register of Historic Places (NR). Grateful acknowledgment is made to Little, Brown, and Company, Publishers, for permission to reprint the excerpt from Dan Rather's *I Remember* (copyright © 1991 by DIR Enterprises, Inc.).

INTRODUCTION

In 1908, Mrs. W. G. Love (Lillian), wife of Houston Heights' first mayor, wrote a chapter for "The Key to the City," a booklet showcasing Houston and its suburbs. Waxing euphoric about her community, Mrs. Love said, "The history of Houston Heights reads like a fairy story in which a magician has waved his magic wand and wonders have sprung into existence." The facts support her imaginary picture. In less than 20 years, the self-made millionaire O. M. Carter and his agents had transformed 1,765 acres of forest into a municipality with a population of 6,000, an artesian water works, 25 miles of graded streets, and shell paving on the east side of the main thoroughfare. Late Victorian–era mansions dotted the impressive boulevard, but Carter did not promote his community as a suburb for the elite. Advertisements stressed the affordability of the neighborhood where lots started at $250 and could be financed by the investors for a $6 down payment and $6 a month. Houston Heights was a streetcar suburb aimed at the blue-collar workers and the middle-class people who worked in downtown Houston. This book is meant to be a reflection of the economic diversity of the neighborhood from the beginning.

As part of the initial planning for the success of Houston Heights, in 1890, Carter purchased Houston's two mule-drawn streetcar systems, which were something of an embarrassment to the city's "progressive" image. Dallas, Fort Worth, San Antonio, and even Galveston were already planning or had established electrification of their transportation systems. Though Carter received a 35-year franchise instead of the 50 years he sought, he proceeded to invest $500,000 electrifying the service as promised. These electric streetcars became an important part of Houston's history and especially the history of Houston Heights. Because of the oftentimes muddy and impassible streets, travel by streetcar played an essential role in the development of early suburbs. The first electric streetcar excursion in Houston Heights occurred on November 13, 1892, and though the line was not yet finished, curious crowds rode out to see the new development. Riding the trolleys soon became a favorite Sunday excursion, and the 5¢ fare was cheap entertainment, affordable for everyone. Because no heating or cooling was available, the company had open streetcars for summer and closed cars for winter.

Eighty-five miles of streets and alleys were surveyed, and about one half of this had been laid out and graded before the first lot was sold. Carter's vision included a grand boulevard patterned after Commonwealth Avenue in Boston, home to several of his investors. Because he felt that one bridge would not preserve the uniformity of the Boulevard's esplanade, twin bridges were constructed to span White Oak Bayou. Such careful planning and generous funding set Carter's company objectives apart from other land companies developing similar communities at that time in Texas. The national Panic of 1893 set the development of Houston Heights back when lots did not sell as fast as Carter had predicted. But within a few short years, the suburb was a thriving residential success with both a manufacturing district and a commercial business center.

Throughout the first three decades of the 20th century, Houston Heights, called the Heights, experienced the same growth and prosperity enjoyed by Houston. In 1918, the citizens sought

and received annexation to the City of Houston, thereby solving the problem of having an adequate school tax base. The transition from an incorporated "village" to a suburb of Houston was surprisingly seamless. News of the thriving community spread, bringing buyers from all areas of the country. A large number of people purchased entire blocks of the reasonably priced land, some to have space for cows, horses, and chickens and some to have room to build homes side by side with their families. It was not uncommon for whole families to settle in newly built adjacent or nearby houses, and the community became fascinatingly intertwined as cousins were schooled with cousins and clubs were filled with fathers and sons, mothers and daughters, aunts and uncles. No other subdivision in Houston has such a major grouping of historic church buildings. The churches prospered, while adding to or replacing their original buildings. Houston Heights became the happy, contented neighborhood Carter had visualized. While some of the residents remained content to stay within the boundaries of their little municipality, others left and made their mark on the world.

Dan Rather, who grew up here in the 1940s, still reminisces about the importance of the distinctive entry to his neighborhood. In his book *I Remember*, he describes Heights Boulevard as a "main drag with a difference" and goes on to explain why. "When I grew up, the boulevard was still ground zero, our center of civilization, our Champs Elyseés. . . . Two bandstands gave it a small-town feeling that might have come out of Thornton Wilder's *Our Town*." Undoubtedly, many residents today share his feelings.

In 1893, the "Houston Illustrated" pamphlet called Houston Heights' real estate "the choicest and most valuable in this section of the country." Newer subdivisions in the South now claim this honor, but a glance at real estate statistics indicates the respectable value still accorded property here today. Houston Heights, along with other inner-city suburbs across the country, suffered decline, disrespect, and shabbiness during the decades of the 1960s, 1970s, and 1980s, but this community was able to resurrect itself.

How did this happen? One important factor was the election held in Houston Heights in 1912 establishing this village as a "dry community." When Houston Heights was annexed to the City of Houston in 1918, the citizens mandated that this regulation be preserved. No bars, strip joints, or taverns are to be found in Houston Heights since the ordinance has been impossible to revoke, though many have tried. Furthermore, Carter had so well planned Houston Heights that in spite of the fact that the City of Houston has no zoning, the commercial area is still segregated from the residential area.

Another important factor has been the 1973 formation of the Houston Heights Association (HHA). Business leaders and concerned citizens joined to find a way to preserve their neighborhood, and their work continues today. HHA holds annual home tours, bike rides, marathons, picnics, and other fund-raisers, generating money that is poured back into the community, keeping the boulevard beautiful, maintaining two parks, and serving as a watchdog for those who would harm the neighborhood. For decades, HHA has encouraged and supported restoration of historical buildings. Recently, two large municipal historic districts have been created by petitions supported by a majority of the property owners. Almost 150 historic buildings have been individually placed on the National Register of Historic Places, and 50 individual buildings have been designated as landmarks of the city of Houston. These historic designations not only recognize important buildings within Houston Heights, but they also honor the incredible achievement of Houston Heights, the earliest and largest planned community in Texas at the time.

One

COMMUNITY

OSCAR MARTIN CARTER. Founder of Houston Heights, Carter was born in Massachusetts and orphaned at an early age. Carter went west with a wagon train and mined for gold. By 1885, this unique and interesting man was directing six banks in Omaha, Nebraska. In 1887, he formed the Omaha and South Texas Land Company and relocated to Houston. Carter's lasting tribute is his development of the planned community, which he named Houston Heights. (HMRC.)

DANIEL DENTON COOLEY. At the age of 38, Cooley moved to Houston Heights with his wife and three young sons to become the general manager of Carter's new company. When he died in 1933, thousands followed the funeral car down the length of Heights Boulevard to pay tribute to the man many called "The Father of Houston Heights." (Courtesy of Talbot Cooley.)

D. D. COOLEY HOME. The home at 1802 was the first to be erected on the Boulevard. The three-story house was clad with cypress siding. A coal-burning furnace in the basement provided central heat. Each room had a speaking tube. The dining room windows featured oval etched ruby glass, believed to repel flies. Eight bedrooms had marble lavatories with hot and cold running water. Tragically it was demolished in 1965 because of serious deterioration. (Courtesy of Talbot Cooley.)

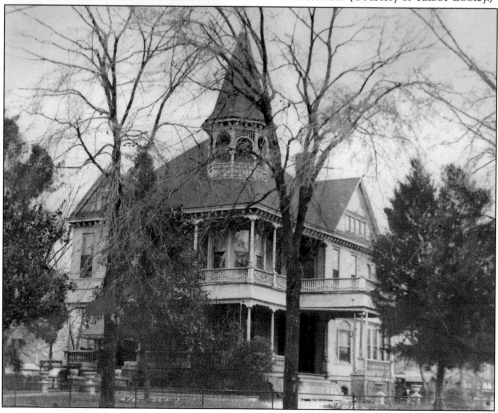

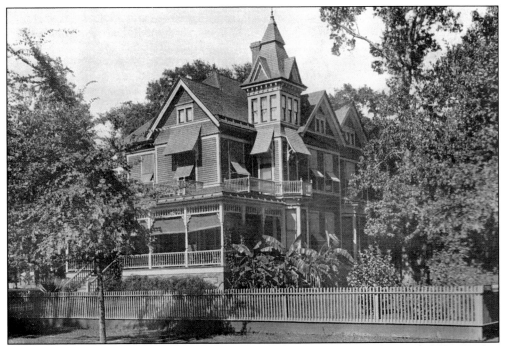

JOHN MILROY HOME. One of Carter's original investors and a native New Yorker like Cooley, Milroy moved to Houston in 1893. He worked for 20 years as general agent for Carter's land company and served eight terms as mayor of Houston Heights. His home at 1102 Boulevard was one of 17 built from George Franklin Barber's plans, and a Milroy descendant lived here until 1981. (Courtesy of Randy Pace; NR, LM.)

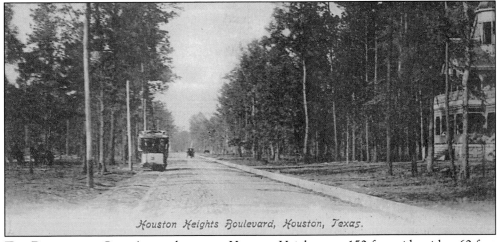

Houston Heights Boulevard, Houston, Texas.

THE BOULEVARD. Carter's grand entry to Houston Heights was 150 feet wide with a 60-foot esplanade. Care was taken during the construction to preserve all native trees, and streetcar tracks were laid along the Boulevard's esplanade so that they would not interfere with the park-like image. (Courtesy of Randy Pace; Esplanade NR.)

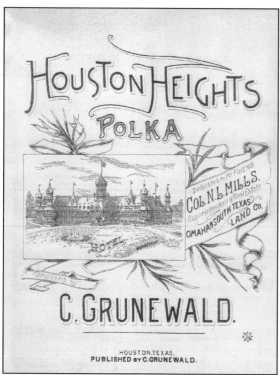

HEIGHTS POLKA. Composed by music store owner Clifford Grunewald, this sheet music was published in Houston in 1893. He dedicated it to his friend Col. Newton L. Mills, who was superintendent of real estate for the land company. The hotel pictured was a fanciful drawing of the building Carter had planned to construct on the northeast corner of West Nineteenth Avenue and Ashland Street. (Courtesy of Randy Pace.)

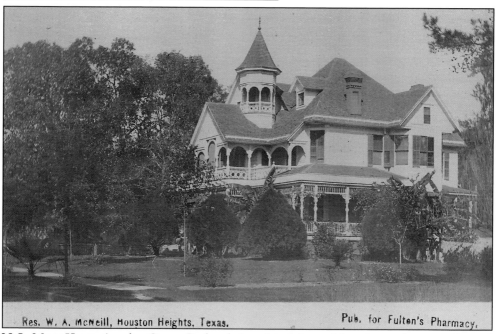

N. L. MILLS HOME. Another George Barber design, this elaborate Victorian-era home was located at 1530 Boulevard. Mills, one of Carter's investors, lived here briefly. After Mills left the Heights, another of Carter's investors, W. A. McNeill, moved in and lived here with his family for 40 years. Considered the most prestigious of all the Boulevard homes with its intricate "gingerbread" exterior woodwork, the house was demolished in 1964. (Courtesy of Randy Pace.)

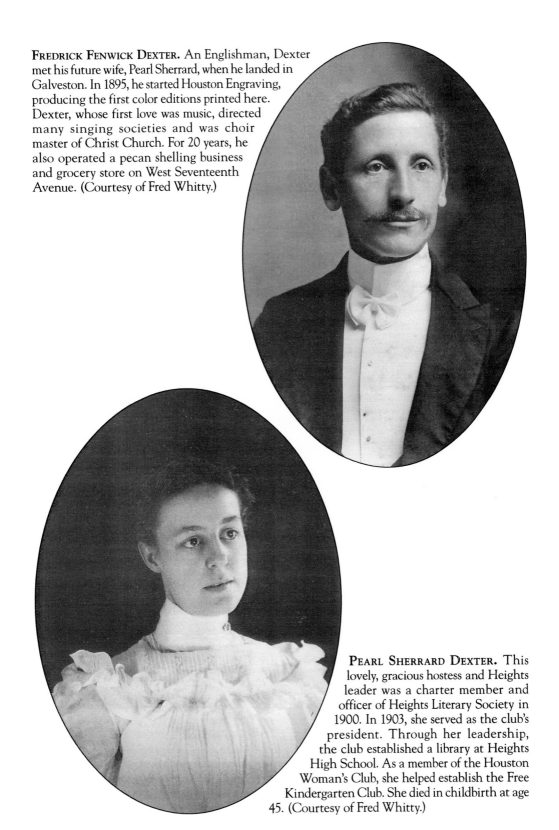

FREDRICK FENWICK DEXTER. An Englishman, Dexter met his future wife, Pearl Sherrard, when he landed in Galveston. In 1895, he started Houston Engraving, producing the first color editions printed here. Dexter, whose first love was music, directed many singing societies and was choir master of Christ Church. For 20 years, he also operated a pecan shelling business and grocery store on West Seventeenth Avenue. (Courtesy of Fred Whitty.)

PEARL SHERRARD DEXTER. This lovely, gracious hostess and Heights leader was a charter member and officer of Heights Literary Society in 1900. In 1903, she served as the club's president. Through her leadership, the club established a library at Heights High School. As a member of the Houston Woman's Club, she helped establish the Free Kindergarten Club. She died in childbirth at age 45. (Courtesy of Fred Whitty.)

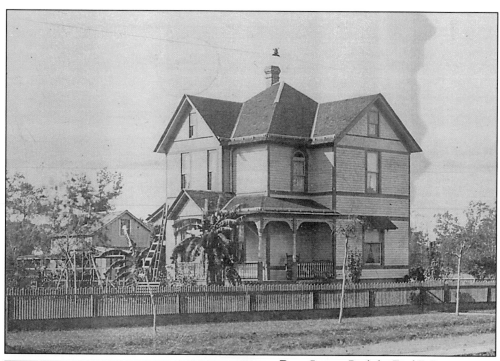

ROSE LAWN. Built by Fred F. Dexter in 1899, this estate occupied the block between Yale and Rutland Streets at 224 West Seventeenth Avenue and was unique for its improvements and grounds. Named for his wife Pearl's beautiful roses, the estate was designed by Dexter. The Queen Anne–style house featured unique arched glass "lunettes" over the front-facing upstairs window and downstairs entry door, trim painted in dark green, and a wooden hood awning over the prominent downstairs window. The house has been demolished. (Courtesy of Fred Whitty.)

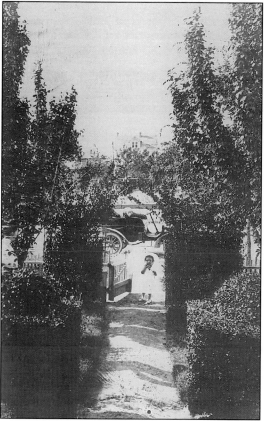

ENTRANCE TO ROSE LAWN. Dexter's estate illustrates Victorian America's passion for nature. The privet hedged gate and smaller topiaries bordered the walk to the home's front door. The trees may have been pollarded, a European method of pruning trees that produced prolific branched growth in the following season. Dorothy Dexter, Fred's daughter, can be seen entering the gate holding her favorite umbrella. (Courtesy of Fred Whitty.)

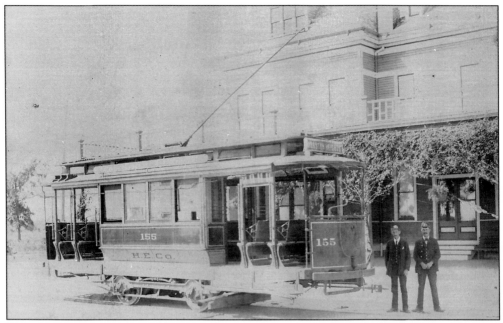

HEIGHTS STREETCAR. These "California" cars manufactured by Stone and Webster were delivered to Houston in 1902. Four were assigned to Houston Heights. Popular in warm climates, the cars featured open sections at each end. Conductors had recently received a 2¢ per hour raise. Assuming they were long-term employees, their new wage was now 17¢ per hour. The streetcar is stopped in front of the Houston Heights Hotel on the northeast corner of West Nineteenth Avenue and Ashland Street. (Courtesy of Upchurch family.)

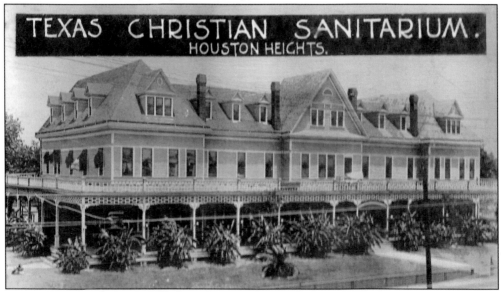

TEXAS CHRISTIAN SANITARIUM. This 1892 building was the 50-room Houston Heights Hotel that Carter actually did build to promote his new real estate venture. U.S. Spanish-American War soldiers, stationed at Camp Tom Ball, often came for meals. An elegant setting for social events, the hotel closed in 1905, and the hotel then became a sanitarium. A group of doctors moved in next. The building burned to the ground June 1, 1915. (HHA.)

IRENE McBRIDE. In 1893, Carter promised Irene McBride and her husband, W. C., six months' free rent if they would open a grocery store and post office on Nineteenth Avenue. Appointed postmistress of Houston Heights on July 7, 1884, she kept letters in a cigar box where residents looked for their mail. She retired from the business in 1897. When natural gas lines were installed in the Heights in 1914, she served Carter, Milroy, McKinney, and others a turkey dinner she had cooked at her restaurant to celebrate the event. McBride remained an active Heights resident until her death. (Courtesy of St. Andrew's Church.)

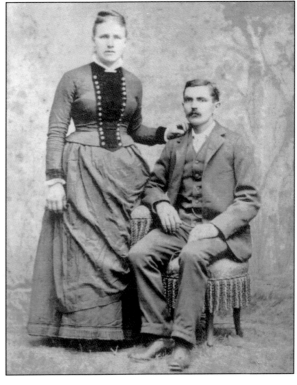

FREDERICK AND MARIANNAH IBSCH. The young couple immigrated to Texas from Prussia. They married in Seguin in 1888 and lived in Dallas and Austin prior to settling in Houston Heights shortly after the turn of the century. They became naturalized citizens in 1908 and had seven children: Anna, Frederick Jr., Marie, Karl, Ernest, Gretchen, and Elsie. (Courtesy of Ibsch family.)

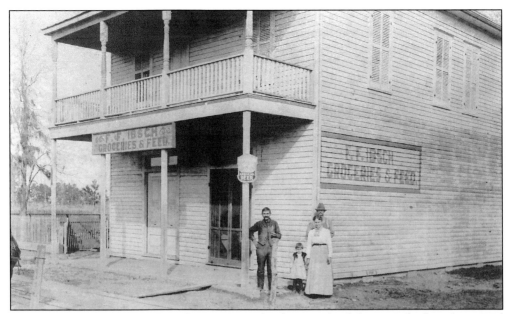

F. F. Ibsch Grocery and Feed Store. An early photograph of the store, built and operated at 2202 Yale Street, pictures, from left to right, Frederick, Mariannah, their daughter, and an unidentified man. Operating his store for 36 years, Ibsch prospered, in part, because he extended credit to many Heights residents. When Mariannah passed away in 1914, he leased the building to Dave Kaplan, but returned to operate his store in 1916. It has since been demolished. (Courtesy of Ibsch family.)

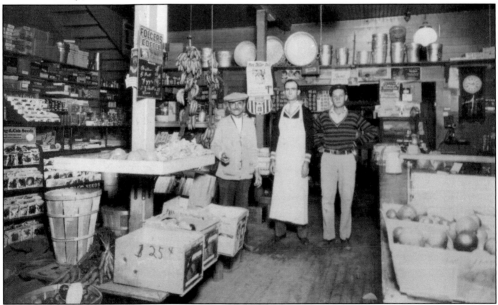

Interior of Ibsch Grocery Store. Pictured are, from left to right, F. F. Ibsch, Mr. Daniel, the butcher, and "Mutt," the delivery boy, overseeing their various wares, which included baskets of fresh produce, a rack of seed packets, and crates with live chickens. Ibsch's success is noteworthy since the 1919 City Directory lists more than 70 family grocery stores in the Heights. (Courtesy of Ibsch family.)

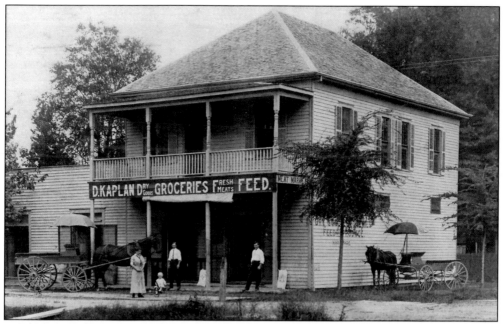

DAVE KAPLAN GENERAL STORE. In 1914, after Kaplan had been in business for a year, he signed a two-year lease with F. F. Ibsch for the building pictured above. When the lease expired, Kaplan purchased the property across the street and built a store on the southwest corner of Yale Street and Twenty-second Avenue. His family lived above the store, as was customary for store owners. (Courtesy of Martin Kaplan.)

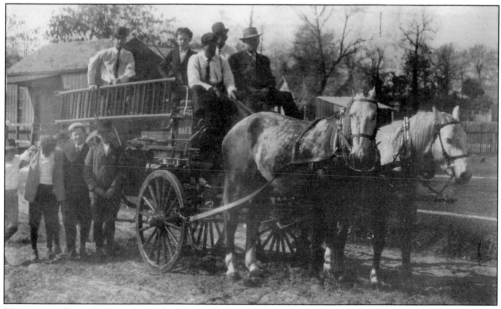

VOLUNTEER FIRE DEPARTMENT. In September 1908, these men organized the unofficial Heights Fire Department. Note the H.H.F.D. designation on the driver's seat. They used a two-tank chemical engine they later sold to Lufkin, Texas. The driver is Horace Olive, the first fire chief. At 908 Yale Street, they constructed a two-story wooden building that served as a firehouse. The group disbanded after a tax-supported fire system was established in 1910. (HMRC.)

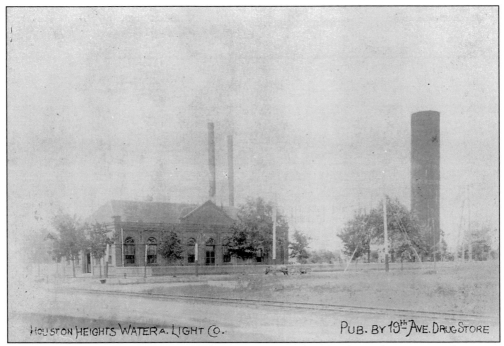

HOUSTON HEIGHTS WATER WORKS. All that remains of this building located on Nineteenth Avenue is the brick fuel tank. Completed on April 27, 1893, the artesian wells and 100-foot standpipe for water storage were Texas's second tallest. The surrounding grounds were beautifully landscaped and were used as a park by children and older residents, who held croquet games there. (Courtesy of Randy Pace; Fuel Tank NR.)

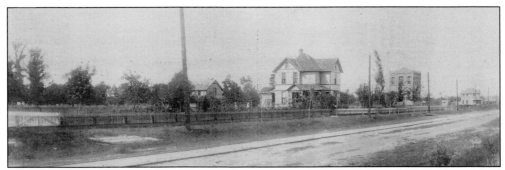

EARLY VIEW OF RUTLAND STREET AND WEST SEVENTEENTH AVENUE. The expanse of Fred Dexter's estate Rose Lawn, with its substantial fencing, is illustrated in relation to the closest brick building, Cooley School. The two-story home in the background housed Sister Agatha's family. Notice the streetcar tracks and the unpaved street that was the norm until the early 1930s. All are now demolished. (Courtesy of Fred Whitty.)

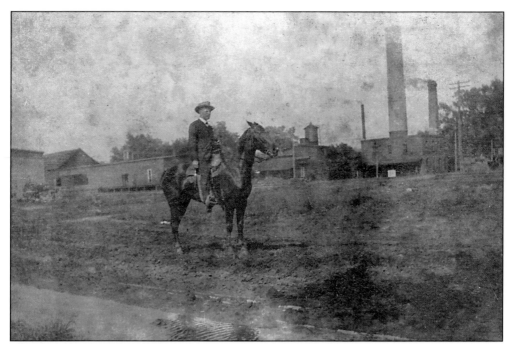

UNIDENTIFIED HORSEMAN. The man on horseback is surveying the newly built industrial section of Houston Heights. The rail service planned by Carter to service this diverse manufacturing district was already in place. (HHA.)

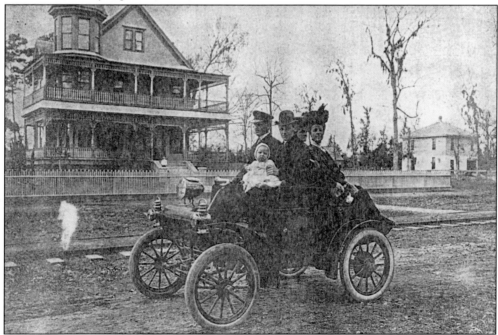

THE DEXTER FAMILY RIDING ON THE BOULEVARD. Fred Dexter is holding on his lap his baby daughter Dorothy, born March 7, 1904. He and his wife, Pearl, are riding down stately Heights Boulevard with the driver of the automobile and another unidentified passenger. (Courtesy of Fred Whitty.)

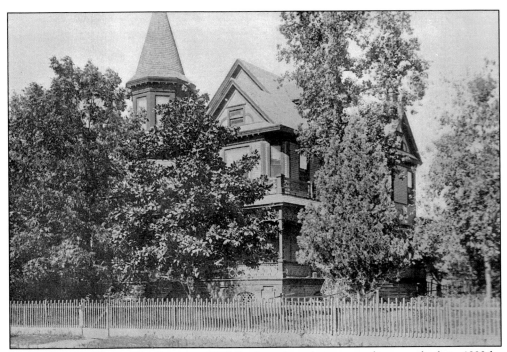

O. M. CARTER HOME. This home at 1320 Boulevard, no longer standing, was built in 1893 by William Shannon, one of Carter's agents. The front parlor served as his real estate office where visitors presented their calling cards. The Rev. Benjamin Rogers family owned the home for 15 years, but finally O. M. Carter, who had never lived on the Boulevard, moved in and lived here until his death in 1928 at the age of 86. During Houston Heights' "Golden Jubilee" celebration, his widow held a reception on the spacious lawn for the community. (HHA.)

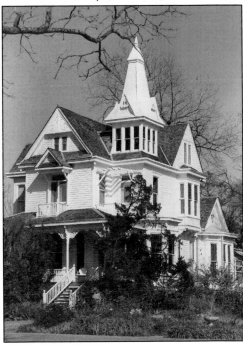

THE TRUXILLO HOME. Built around 1892, the home at 1802 Harvard Street is one of two surviving Heights Barber houses. A side gable window features a Lone Star of Texas motif, supporting neighborhood lore that the house was built for a retired Texas governor who died before its completion. The two-story, 20-room Victorian-era home, built in the Queen Anne/Stick styles, features a dominant tower. Still containing its original interior woodwork, floors, and "electric lights," this home is a Heights treasure. (Courtesy of Thorp family; NR, LM.)

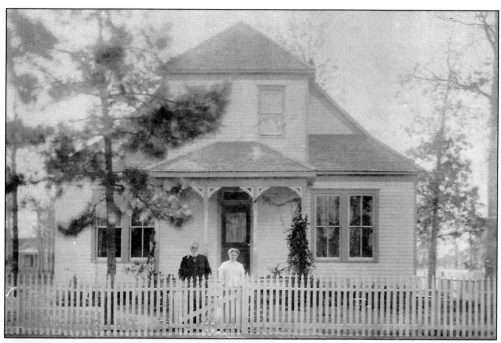

DAVID BARKER'S FIRST HOME. Located at Sixteenth Avenue and Cortlandt Street (and now demolished), this is the home where Barker brought his wife in 1905. They lived here until he built the larger home one block away at Sixteenth Avenue and Harvard Street. (Courtesy of Gail Rosenthal.)

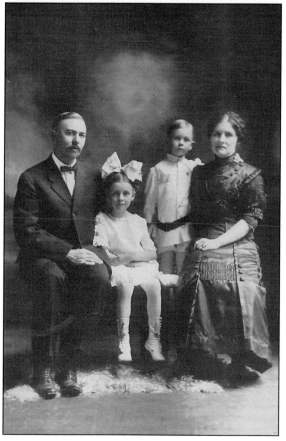

DAVID BARKER FAMILY. An Illinois native, Barker came to Galveston on a $15 railroad excursion, decided he liked the state, and went back to get his wife, Pauline, settling in Houston Heights. Barker served as mayor from 1907 to 1913. In 1928, he became land and tax commissioner of the City of Houston, the first city official elected from the Heights. Barker is pictured with Pauline, daughter Bernice, and son Elmer. (Courtesy of Gail Rosenthal.)

121 EAST SIXTEENTH AVENUE. For the rest of their lives, David and Pauline Barker lived in this house he built in 1913. Both were charter members of Grace Methodist Church. Their daughter Bernice, after her graduation from Heights High and Rice Institute, remained prominent in the Heights. An outstanding Reagan High School educator, she taught English and sponsored the Red Coats for years before being appointed dean of women. (Courtesy of Thorp family; NR, LM.)

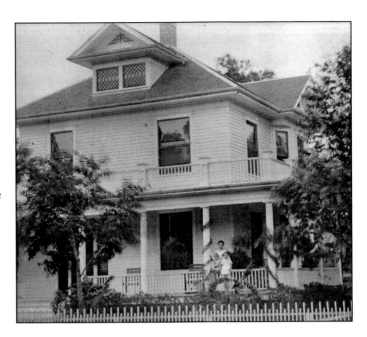

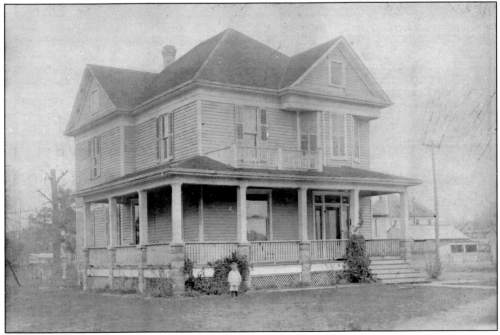

WHITTY HOME. This custom-built residence at 124 West Seventeenth Avenue features a mix of Queen Anne and Colonial Revival styles. It resembles several of the Sears Roebuck models but is not a "kit" house. Frank Newbanks was probably the builder. The beveled-glass front door, sidelights, and transom are original to the house. Members of the Whitty family were active Heights residents, and their son married Fred Dexter's daughter. (Courtesy of Ann Davidson; LM.)

23

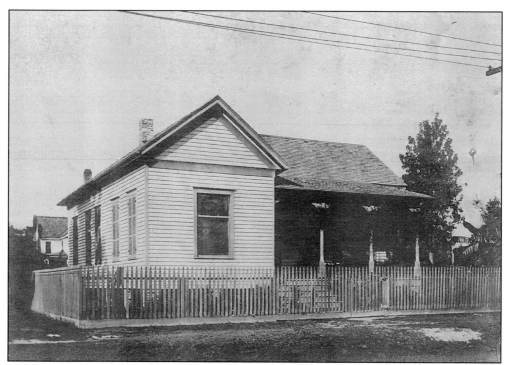

THE UPCHURCH COTTAGE. Located at 301 East Fourteenth Avenue, this 1906 home is a modified L-plan Queen Anne–style home. Robert Hickman Upchurch, a streetcar conductor, purchased the home and extra lot from O. M. Carter for $320. Upchurch lived here with his wife, Fannie Ella, and three daughters. A traditional wood picket fence surrounded the home and yard. (Courtesy of Upchurch family; NR.)

WAGON IN FRONT OF 301 EAST FOURTEENTH AVENUE. A typical enclosed delivery wagon with oval-shaped side view windows is parked at the Upchurch home. Note the mud-encrusted wheels indicating the condition of most Houston Heights streets in the early 20th century. (Courtesy of Upchurch family.)

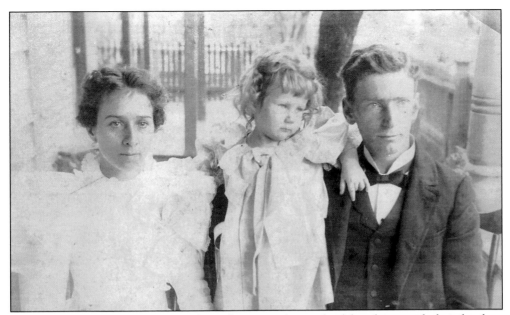

UPCHURCH FAMILY. The young couple is relaxing on the porch of their home with their daughter Blanche. Upchurch wanted to name her Heliotrope for a favorite passenger who rode his streetcar. His wife refused, but when their third daughter was born, he got his wish. Dressed in rather formal attire, the family may have just come from church. (Courtesy of Upchurch family.)

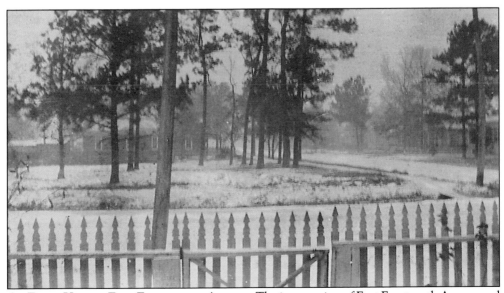

AN EARLY VIEW OF EAST FOURTEENTH AVENUE. The intersection of East Fourteenth Avenue and Cortlandt Street is seen through the front gate of the Upchurch home. The empty lots indicate the sparse settlement of Houston Heights at this time, when tall pine trees dotted the landscape. (Courtesy of Upchurch family.)

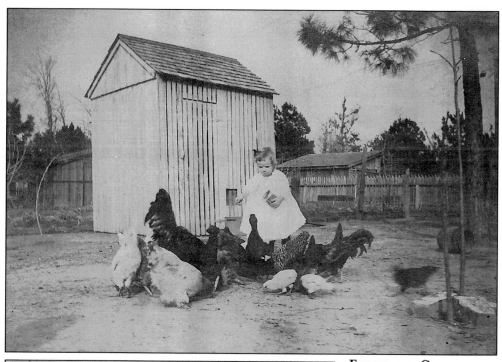

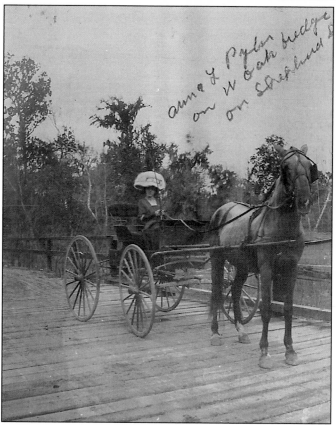

alma L Pyle bridge on W Oak on Shepherd S

FEEDING THE CHICKENS. Blanche Upchurch is in the backyard of her home scattering feed, a common chore, for a flock of Plymouth Rock chickens. The yard is bare ground, indicating that probably the chickens ran loose. (Courtesy of Upchurch family.)

SHEPHERD DRIVE BRIDGE. Alma Louise Pyles is driving her buggy across White Oak Bayou at Shepherd Drive in 1909 on the outskirts of Houston Heights. Her mother, Mariah L. Pyle, had taught her that the term "giddyap" was rather vulgar, and instead she was to direct her horses thusly: "We will now proceed." (Courtesy of Wyatt family.)

BURNETT HOUSE. When George Burnett lost his entire family in the Galveston storm of 1900, he relocated to Houston where he built his new home at 219 West Eleventh Avenue. A raised Victorian-era cottage (which he raised even higher than usual), it featured a Queen Anne wraparound porch and gingerbread fretwork. Burnett remarried a Houston Heights woman, Myrtle Redwine. Their son, George Jr., resided in the house until his death in 2003. The home is owned by Burnett's grandson. (Courtesy of Arlen Ferguson; NR, LM.)

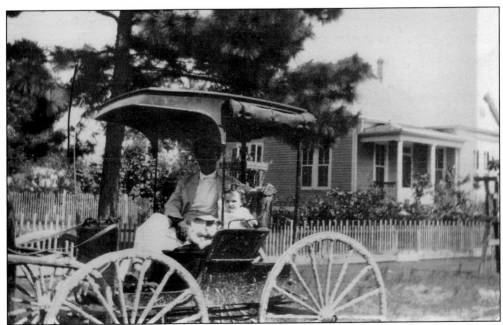

DR. GUFFIE ROBINSON. Robinson first rode a streetcar to Houston Heights in 1906, looking for a place to practice medicine. He loved the newness of the community. He rented space above Nineteenth Avenue Drugs and was appointed Heights city health officer in 1908. A horse-and-buggy doctor, within two years, he had established his practice, charging a $25 flat fee for the delivery of a baby. Shirley, his firstborn, is with him in the buggy. Robinson hung his doctor shingle at his in-laws' home at 1230 Harvard Street before he moved the family to 130 West Eighteenth Avenue in 1913. (Courtesy of Robinson family.)

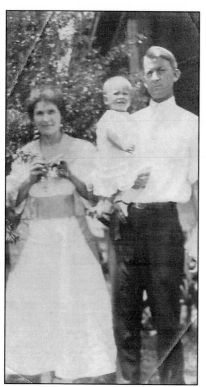

JOHN DUNLOP FAMILY. The Dunlops came to Houston Heights in 1913. Dunlop is pictured with his family at 526 West Twentieth Avenue the year he was appointed Houston Heights' postmaster. In 1915, the Tuesday Social Club was formed at this home. Transferred downtown in 1917, Dunlop became postmaster of the city of Houston in 1947. Lifelong Heights residents, the Dunlops were active members of Heights Christian Church. His wife, Mamie, riding down Yale Street just after a rain, realized the lack of drainage. Knowing storm sewers and paving had been voted on, she was outraged the work had not been done. Her three-year fight with Mayor Oscar Holcombe ended in 1930 when Yale Street was finally paved with asphalt. (Courtesy of Jill Kershner.)

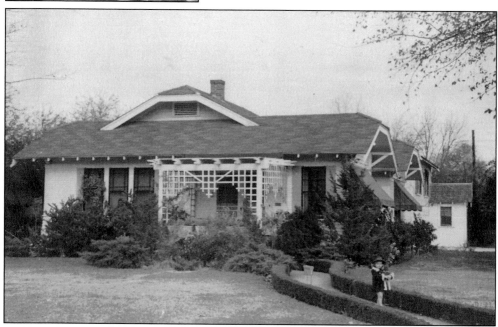

DUNLOP HOME. In 1925, the Dunlop family moved into this bungalow at 401 West Twenty-third Avenue. By fall, this home was selected as the first grand prize garden in Class A in the city of Houston. The Dunlops were presented with a beautiful sterling silver vase by the sponsors, the First National Bank of Houston and the *Houston Chronicle*. Mamie Dunlop had already won a $10 prize from the Heights Civic Improvement Club contest. (Courtesy of Jill Kershner.)

Two

SCHOOLS

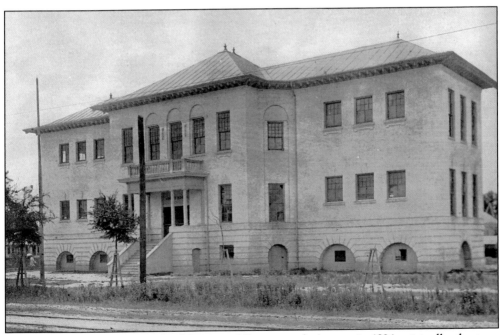

COOLEY SCHOOL. Built at Rutland Street and Seventeenth Avenue in 1894, originally, the two-story red-brick structure had only one room downstairs and upstairs. Mrs. Helen Cooley sold $900 worth of her jewelry to help buy a kiln to fire the bricks used. Because D. D. Cooley had led the way for this first school to open in Houston Heights, the building was named after him. In 1906, wings were added and the exterior was covered in stucco. (HHA.)

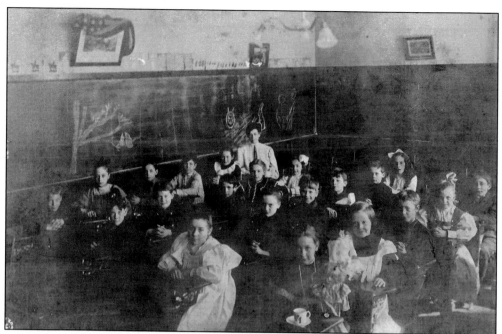

ELEMENTARY SCHOOL CLASSROOM. Probably taken at Cooley Elementary in 1916, this is a posed classroom photograph with unidentified students clasping their hands as instructed. Note the plaster walls with the upper wood picture rail. Artwork in chalk is on the blackboard. The once gaslight fixture has been converted to electric. Two girls have their dolls in the photograph, and the girl in the front right has a teacup on her desk. (HHA.)

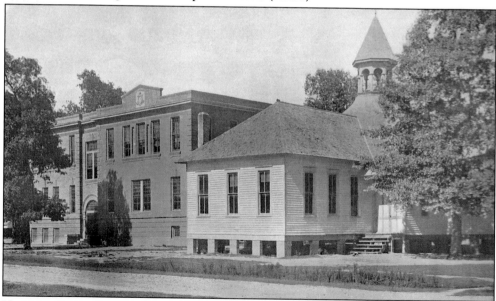

HARVARD STREET SCHOOL. The word "Street" was dropped from its title when the brick building to the left was built in 1911 (now demolished). The original frame structure was constructed for $604.35 in 1898. City council minutes recorded a cost of 45¢ for chalk, 75¢ for erasers, and 50¢ for a hand belt. Obviously, city fathers adhered to the prevailing child-rearing philosophy, "Spare the rod and spoil the child." (HHA.)

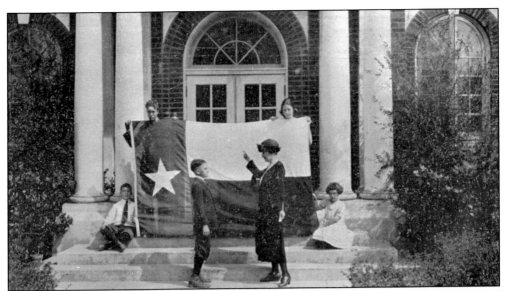

JAMES HELMS ELEMENTARY SCHOOL. This building at 503 West Twenty-first Avenue opened in 1921 at a cost of $49,000. Named after a Heights School Board member, the 150-foot-long building, faced with red brick, had eight classrooms, a small auditorium, two playrooms and two toilet rooms, one for girls and one for boys. It was heated by steam. The Texas flag presentation was considered significant because, as stated in the Helms yearbook, "the majority of the students were native born Texans and very proud of it," unlike their parents, most of whom had come from the Midwest and Northeast to settle in Houston Heights. (HHA.)

HEIGHTS HIGH SCHOOL PINE VIEW. Early advertisements invited buyers to "come out to the beautiful Houston Heights where pine trees grow so high they tickle the toes of the angels." In this 1921 photograph, the brand-new Heights High School designed by Maurice J. Sullivan is almost obscured by the native pines. Graduates bought their commencement invitations from Cargill Stationery, and a 1923 receipt of Bernice Barker's lists 70 invitations at 9½¢ each. Located at the north end of the Boulevard, the building is now Hamilton Middle School. (HHA.)

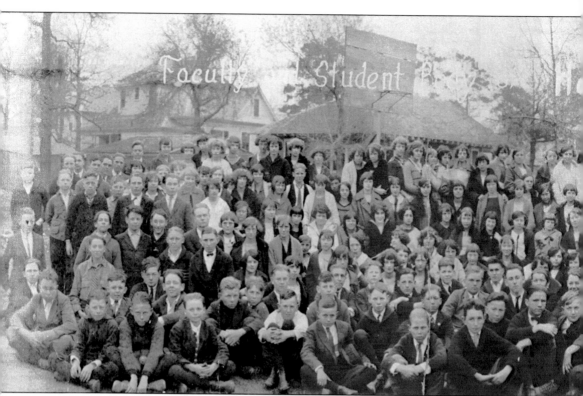

Faculty and Student Body

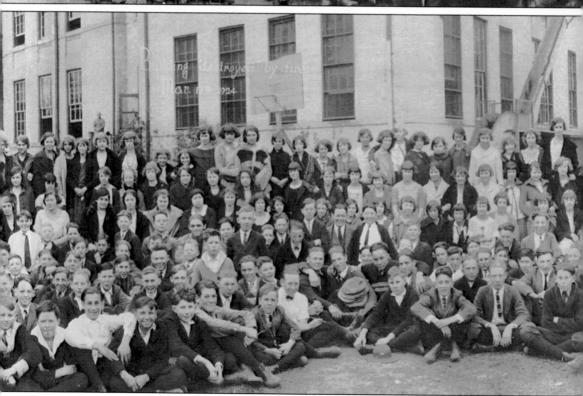

Building destroyed by fire Mar. 1924

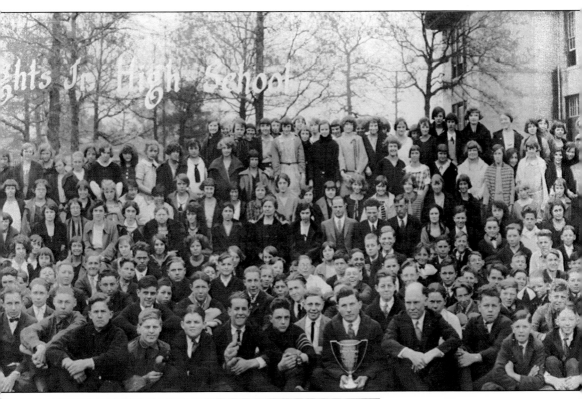

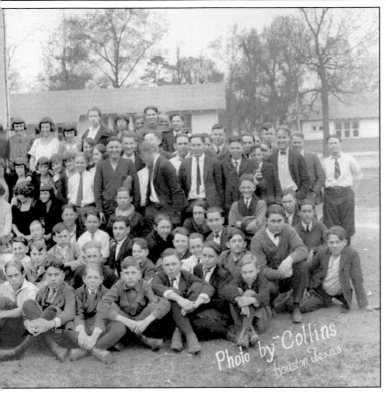

Photo by Collins
Houston Texas

HOUSTON HEIGHTS JUNIOR HIGH. Located on the northwest corner of Yale Street and Twelfth Avenue, this building was erected in 1904. It served as the Heights High School until the construction of the new building on West Twentieth and Boulevard in 1921. This photograph taken in 1922 indicates the sizable junior high enrollment that had already moved into the old Heights High facility. Unfortunately, the building burned on March 13, 1924. This site is now the location of Houston's Milroy Park. (Courtesy of Shirley Townsend.)

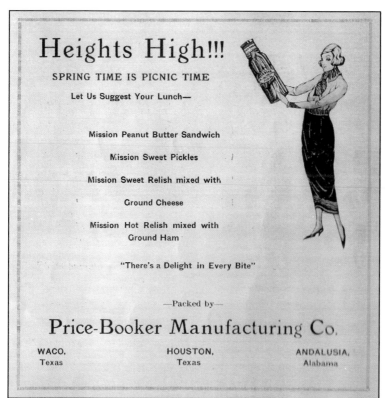

Heights High!!!

SPRING TIME IS PICNIC TIME

Let Us Suggest Your Lunch—

Mission Peanut Butter Sandwich

Mission Sweet Pickles

Mission Sweet Relish mixed with

Ground Cheese

Mission Hot Relish mixed with
Ground Ham

"There's a Delight in Every Bite"

—Packed by—

Price-Booker Manufacturing Co.

WACO,
Texas

HOUSTON,
Texas

ANDALUSIA,
Alabama

PRICE-BOOKER MANUFACTURING COMPANY PICNIC ADVERTISEMENT. This successful statewide company at 2401 Railroad Street (Nicholson Street), otherwise known as "The Pickle Factory," has wonderful suggestions for students' lunches. Their production of pickles, preserves, and peanut butter were products carried in most Houston Heights grocery stores. (HHA.)

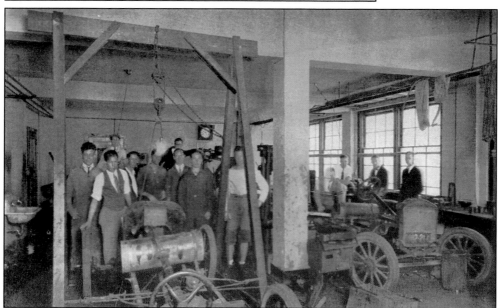

AUTO MECHANICS CLASS. Houston began its romance with automobiles early on. Both Heights High and Reagan High trained students in automobile construction, repair, and upkeep in this "working man" neighborhood. The course description states, "Second hand chassis can easily be built into stream line [sic] speedsters at very little expense." Harris County registered 34,869 automobiles in 1922. Eight years later, nearly 100,000 licenses were issued. (Courtesy of Joe Kennedy.)

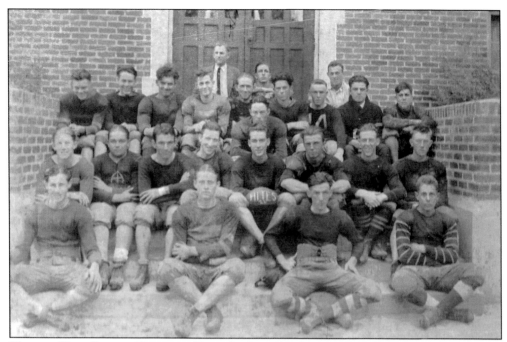

HEIGHTS HIGH SCHOOL FOOTBALL TEAM. In this 1922 photograph, J. B. Marmion Jr. wears the torn jersey. He tore it in a game, and after much debate, the school agreed for him to be in the photograph. In the first row (second from the right) is Bob Waltrip, who in 1926 with his mother would found Heights Funeral Home. Bob's father, Principal S. P. Waltrip, is the gentleman in coat and tie in the back row. S. P. Waltrip High School was named for this well-respected educator. Note the word "Hites" on the football. (HHA.)

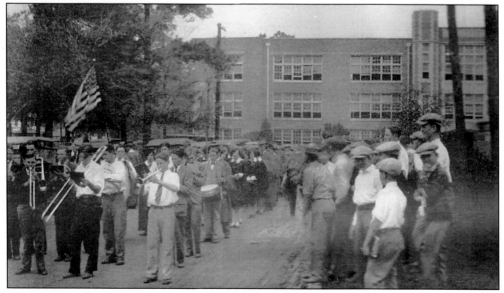

MARCHING TO REAGAN HIGH SCHOOL. In 1926, the students begin their symbolic march from the old Heights High at 139 East Twentieth Avenue to the new Reagan High School, located at 401 East Thirteenth Avenue. The graduates that year wore a class ring with a Heights High insignia, but their diploma was imprinted John H. Reagan Senior High School. (Courtesy of Joe Kennedy.)

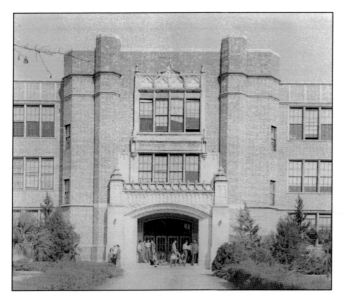

JOHN REAGAN HIGH SCHOOL. Architect John Staub designed the 1926 Tudor Gothic building, which incoming seniors called a "fortress-like stockade." Their class poem laments leaving "grand old Heights" and entering "strange, uncharted seas," surprising sentiments since their principal S. P. Waltrip and most of the faculty came with them. They also kept the school colors (maroon and white), the school mascot (bulldog), and the name of the yearbook (the *Pennant*). (Courtesy of Joe Kennedy.)

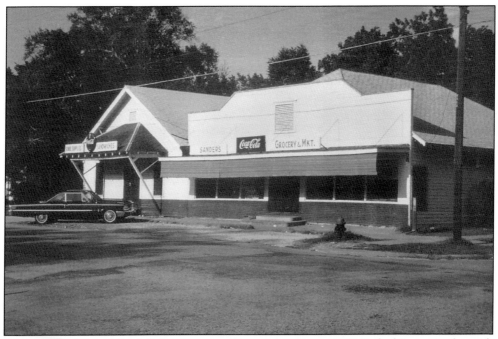

SANDER'S GROCERY. Adolph F. Sander opened a grocery store at 1309 Oxford Street in the mid-1920s. When he died, his son Walter took over the store. Located across the street from Reagan High School, the store became an unauthorized annex to the school. Students were not allowed to leave the campus during school hours, but guys would disobey the rules and go to Sander's. The coaches checked the store regularly for offenders, but Mrs. Adolph Sander (Melinda) would hide them in her storage room. Students were happy to risk a paddling to run over there and get a hamburger for lunch. (Courtesy of Sander family.)

THE 1949 CHAMPIONSHIP TRACK TEAM. Coach "Uncle Joe" Turner's team won the city and state championships. Their star was sophomore Joe Villareal (first row, left). College was delayed for Joe while he fought four years in Korea. He entered the University of Texas on a track scholarship and in 1958 was ranked No. 6 in the world for the 1-mile event. He coached at Reagan until 1963, when the Mexican Olympic Committee invited him to train their 1968 team. The two students (center) on the second row were cocaptains, Albert Kleb (left) and Edward Davis (right). (Courtesy of A. B. Kleb.)

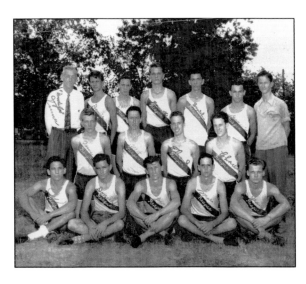

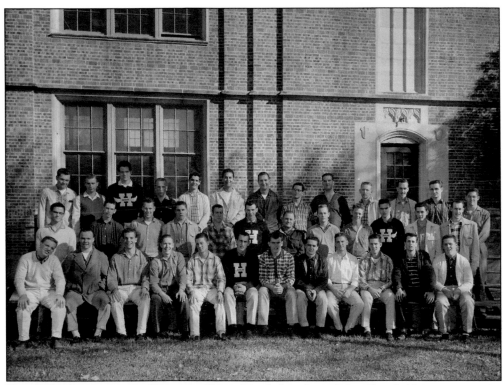

THE 1958 CHAMPIONSHIP FOOTBALL TEAM. Newly hired coach Joe Tusa led his teams to city championships this year and the next, Reagan's last football city honors. The opening of S. P. Waltrip High School in 1960 diminished Reagan's athletic strength. (Courtesy of Joe Tusa.)

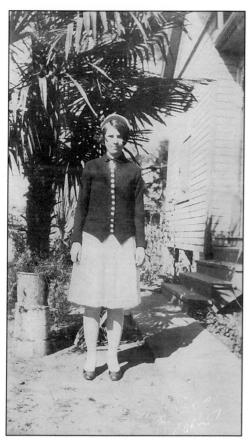

REAGAN RED COATS. In October 1926, Reagan High School teacher Byrd Creekmore organized 60 girls into an organization to "create spirit and render service to the school." In 1930, the drum and bugle corps were added. Pictured is Heliotrope Upchurch wearing the first Red Coat "costume." (Courtesy of Upchurch family.)

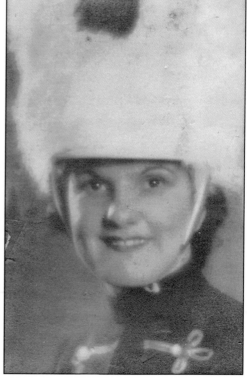

ELIZABETH WEATHERFORD LEE. Drum major (top officer) of the Red Coats, Lee led the drill team in 1936–1937. One hundred girls were featured at San Antonio's Battle of Flowers where they took first place in the Drill Competition. Mrs. Clayton Lee, or Ms. Libby as she is now known, still continues her role of service in Houston Heights. (Courtesy of Libby Lee.)

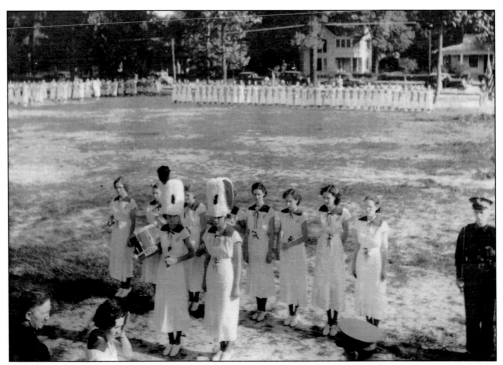

RED COAT PRACTICE FIELD. Pictured on the practice field, located one block from the school, are the Red Coats wearing their 1936 spring uniform, homemade dresses, the design of which was changed every year. The members wore them to school on specified days. Red Coat sponsor Bernice Barker Gale is in the lower left-hand corner. She had her own Red Coat uniform and would sometimes march with the members. Leading the practice are, from left to right, Weatherford and Doris Krueger. (Courtesy of Libby Lee.)

RED COATS IN MEXICO CITY. Drum major Dorothy Green and drill master Frances Beaty are on the field leading the drum and bugle corps that marched before 30,000 spectators in October 1937. This trip, made possible by the generosity of Houston businessmen, led by Mayor R. H. Fonville, was applauded by the *Houston Chronicle* as the "biggest official reception ever given an American group." (Courtesy of Dorothy Green Suman.)

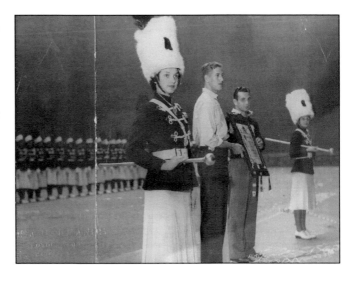

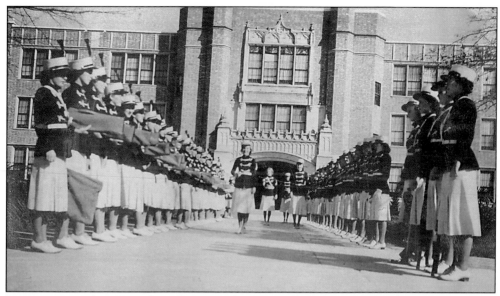

LINING UP FOR ARMISTICE DAY PARADE. The Reagan Red Coats are lined up ready to go to downtown Houston to march in the parade. The members wear the "stunning new uniform of the military type," adopted in 1933. The maroon wool jackets, pleated wool skirts, laced-up leather oxfords, and French Foreign Legion–type hats were unbearably hot during Houston's warm fall weather. It was not uncommon for members to faint before, during, or after performances. The first aider was equipped with smelling salts. (HHA.)

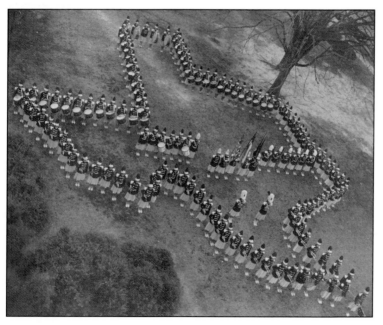

RED COATS IN FORMATION. Taken from the roof of Reagan High School where spotters stood to check the lines, this 1948 photograph shows a classic Red Coat performance formation. The drill team is led by drum major Frankie Payne and drill master Dolores Tousek. The Red Coats took top honors again that year at the "Battle of the Flowers" in San Antonio. (Courtesy of Dolores Tousek.)

Three

CHURCHES

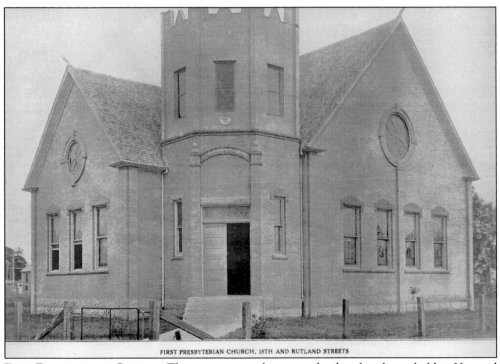

FIRST PRESBYTERIAN CHURCH, 18TH AND RUTLAND STREETS

FIRST PRESBYTERIAN CHURCH. The organizational meeting for this church was held in Harvard Street School on July 19, 1903. Led by Rev. Br. Bob Wear, by 1906, the congregation had moved into this substantial brick building (now demolished) on the southeast corner of Eighteenth Avenue and Rutland Street. (HHA.)

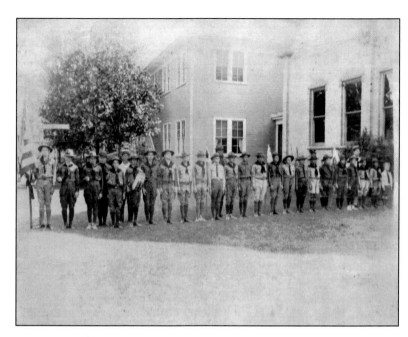

BOY SCOUTS OF AMERICA TROOP 24. The troop is pictured here behind Heights Presbyterian Church in 1924 where its meetings were held. The leader was Bateman Hardcastle. Using World War I army bugles, Clayton Lee blew the bugle morning and evening to raise and lower the flag at Hamilton Middle School. (HHA.)

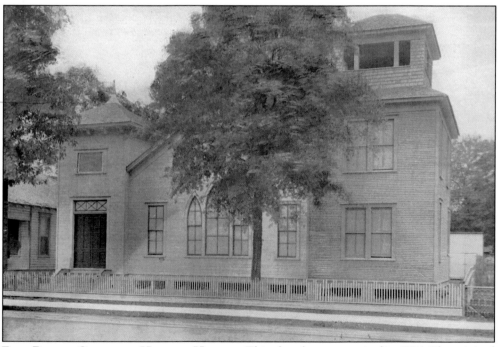

FIRST BAPTIST CHURCH OF HOUSTON HEIGHTS. This church was organized in 1904. The original building shown in the above photograph was located at 919 Yale Street. More room was soon needed. The property was sold, and services were held in the high school until a permanent location was found. The church is now located at 201 East Ninth Avenue, and the original building is demolished. (HHA.)

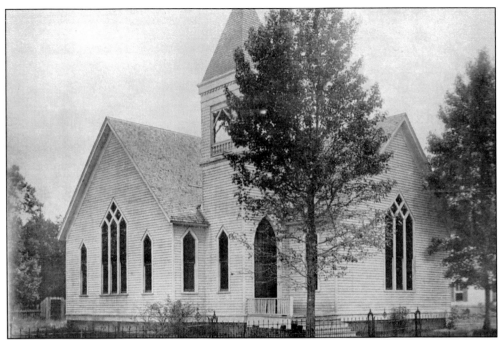

FIRST METHODIST EPISCOPAL CHURCH. The frame building was constructed in 1906 at East Tenth Avenue and Harvard Street by parishioners under the direction of Rev. M. D. Collins. Collins died as the building was being completed, and his funeral was the first service held in the church. The congregation voted to rename the church (no longer standing) Collins Memorial Methodist in his honor. (HHA.)

GRACE METHODIST CHURCH. In 1905, the Ladies Home Missionary Society of Houston Heights met to organize Grace Methodist. They chose a lot on Thirteenth Avenue and Harvard Street. When the men became involved, this lot was traded for one at Thirteenth Avenue and Yale Street. The congregation moved into this red-brick building in 1912. The horse hitching rings built into the curbs on East Thirteenth Avenue are still there. (Courtesy of Grace Church.)

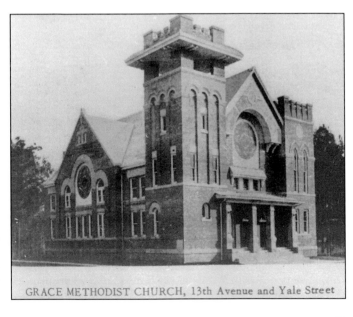

GRACE METHODIST CHURCH, 13th Avenue and Yale Street

43

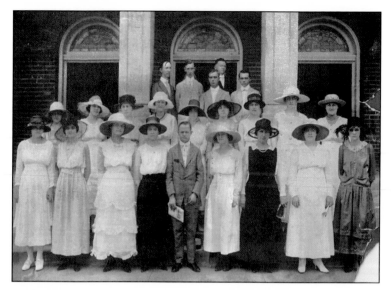

THE FIRST LADIES OF GRACE METHODIST CHURCH. Pictured is a group of ladies called "the First Ladies of Grace Methodist," who formed the Home Missionary Society. They are standing in front of the new building in 1914. (Courtesy of Grace Church.)

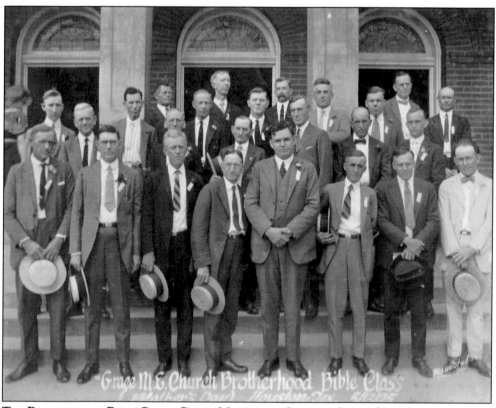

THE BROTHERHOOD BIBLE CLASS, GRACE METHODIST CHURCH. Pictured are the supporters of Grace Church, most of whom were community leaders. The large man at center front is William C. Martin, who was the 12th pastor of Grace. He was later elected bishop of the Methodist Church for the Dallas–Fort Worth area. (Courtesy of Grace Church.)

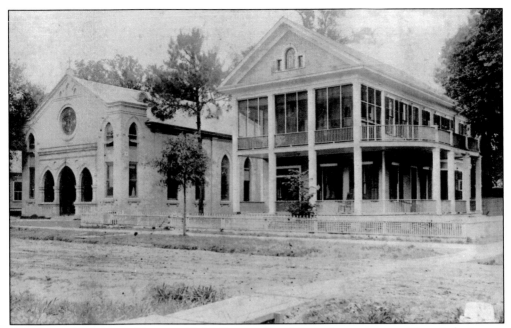

ALL SAINTS CATHOLIC CHURCH. O. M. Carter offered them the property at Twentieth Avenue and Boulevard, but the congregation wanted a "central location," so they chose Ninth Avenue and Harvard Street. The church building was completed in 1909. The adjacent rectory, which was built in 1912 in the neoclassical style, was moved in 1926 to 943½ Cortlandt Street. It took two days and a team of mules to relocate the house. (Courtesy of All Saints Church.)

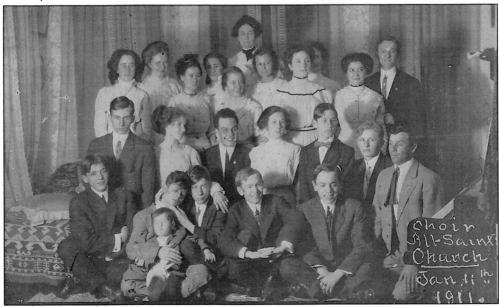

ALL SAINTS CHOIR. By 1911, All Saints organized this choir under the direction of Agnes Gilmour, a volunteer organist. Young people of the parish pictured above sang High Mass as well as the evening devotions. The prayer books contained an English translation opposite the Latin words. The music was described by parishioner Mrs. John Zagst as being "majestic and inspiring." (Courtesy of All Saints Church.)

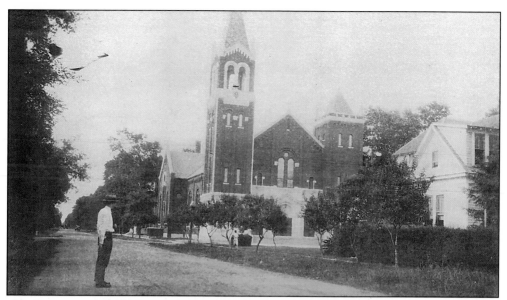

NEW CHURCH FOR ALL SAINTS. The distinctive red and white brick Romanesque Revival building was dedicated in 1927. Services are still held here daily at 1002 Harvard Street. An unidentified man wearing a straw bowler is standing in the middle of the unpaved block of Harvard Street gazing at the new church shortly after it opened. (Courtesy of All Saints Church; NR.)

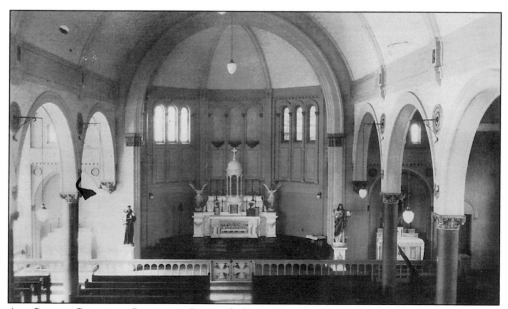

ALL SAINTS CATHOLIC INTERIOR. Pictured about 10 years after its opening, the interior was beautifully appointed with religious statuary and icons. Note the three arched stained-glass windows on either side of the altar. (Courtesy of All Saints Church.)

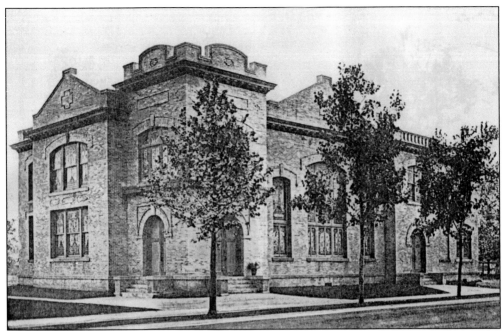

BAPTIST TEMPLE. In 1908, Baptist Temple was formed above Thomas J. Rudledge Grocery Store at 411 West Nineteenth Street. This church was for Baptists who lived in the north end of the Heights. The congregation built this church in 1912 on the southeast corner of Twentieth Avenue and Rutland Street, land donated by O. M. Carter. The only library in Houston Heights before annexation was at Baptist Temple. Dedicated in June 1909, the building cost $15,000. (HHA.)

DR. THOMAS C. JESTER. Born in Alabama in 1884, Jester graduated from Howard College and came to Fort Worth to attend Southwest Baptist Theological Seminary. He was called to Baptist Temple in 1927 and preached his first sermon there on October 2. He remained pastor there until his death in January 1950. T. C. Jester Boulevard was named in his honor. He built the handsome red-brick Colonial-style home at 317 West Twentieth Avenue in 1928. (Courtesy of Libby Lee.)

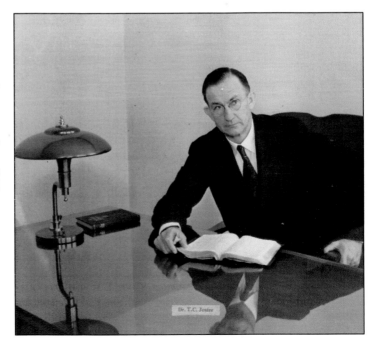

H. J. Brown House. In 1911, St. Andrew's Episcopal Church was organized in the front parlors of this home at 212 West Nineteenth Avenue. Fred F. Dexter, Daniel Denton Cooley, and Irene McBride were among the charter members. The church's name was chosen to honor Rev. Benjamin Andrew Rogers, who organized and held the first non-denominational services that between 1896 and 1903 became St. Stephen's Mission. They first met at Cooley School and then Houston Heights Hotel. The Brown family lived in this now-demolished home until the 1960s. (Courtesy of Marjorie Griffiths.)

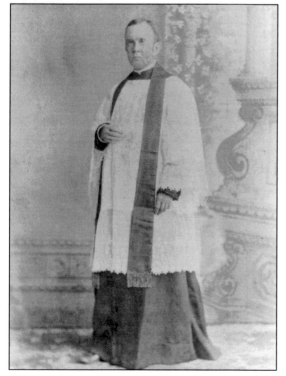

Henry Justus Brown. Born and educated in Virginia, he came to Texas in 1875. He served as rector for St. Mary's and Trinity Episcopal Missions. He and his wife, Auby, had 10 children and were active in the community. (Courtesy of Marjorie Griffiths.)

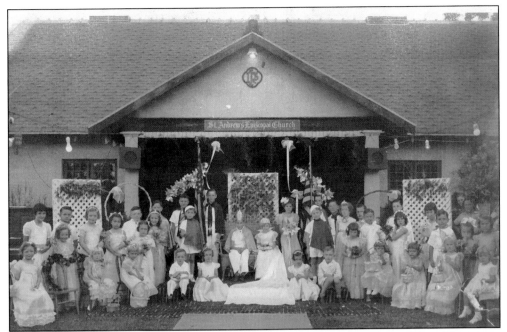

St. Andrew's Mayfete. The young people of St. Andrew's pose in front of the white stucco church (now demolished) located on the southwest corner of Nineteenth Avenue and Yale Street, constructed in 1921. Brother T. C. Jester complained vigorously about the youth group's dances held weekly at the church. (Courtesy of St. Andrew's Church.)

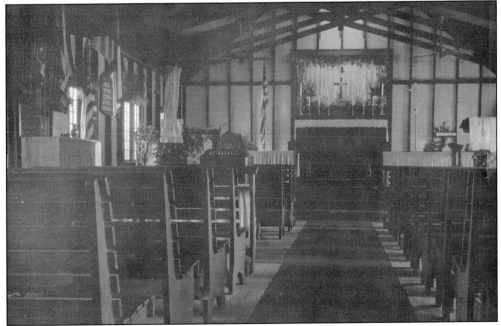

Interior of St. Andrew's Stucco Church. This Craftsman-style sanctuary illustrates the small congregation and their limited means. The pews are similar to park benches, and simple cloth is draped over the altar rails. The ceiling fans were the only source of cooling, and gas space heaters were used for heat. (Courtesy of St. Andrew's Church.)

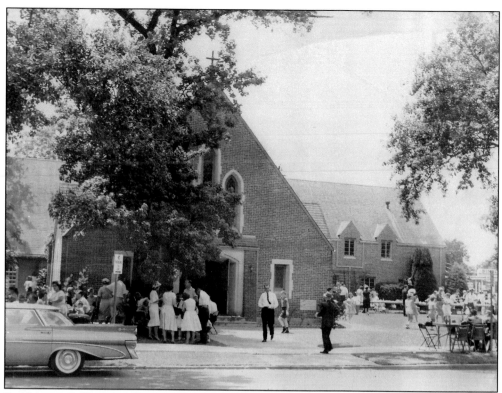

ST. ANDREW'S CURRENT CHURCH. In 1946, the church sold its property on three corners of Yale Street and West Nineteenth Avenue in order to buy the lots on Heights Boulevard. The red-brick building located on the corner of Boulevard and West Nineteenth Avenue opened in 1947. The women of the church purchased folding chairs at a cost of $1.25 each, and the members struggled with the muddy path to the sanctuary for two years. Pews and a sidewalk came later. (Courtesy of St. Andrew's Church.)

FR. HASKIN LITTLE. In 1952, Father Little came to Houston Heights as rector of St. Andrew's. Though a Virginian who was fairly new to Texas, he recognized he had found a home. For 25 years, he guided his church, increasing its congregation fourfold. One reason for his success was his serious commitment to this community. Heights Tower and Heights House, the retirement buildings sponsored by five area churches, were two of his pet projects. After his retirement, he lunched at Heights Tower cafeteria regularly or sometimes just dropped by to play the piano for the residents. (Courtesy of St. Andrew's Church.)

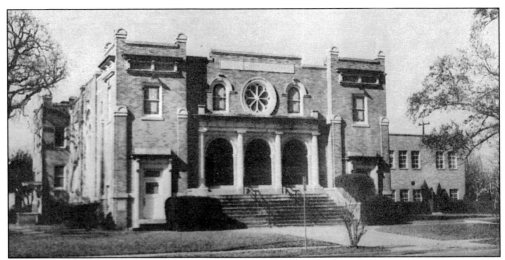

HEIGHTS CHRISTIAN CHURCH. It began in the upstairs room of Fred Dexter's grocery store. In 1912, they bought lots at Seventeenth Avenue and Rutland Street and erected a tent and then a wooden church, which they used for 15 years. In 1927, they built the impressive neoclassical-style structure at a cost of $39,904.30. Dr. Thomas Sinclair was chairman of the building committee. In 1961, a newer sanctuary was built nearby, leaving the historic building intact. It is now home to theater groups, among them Opera in the Heights, a nationally recognized regional opera company. (HHA.)

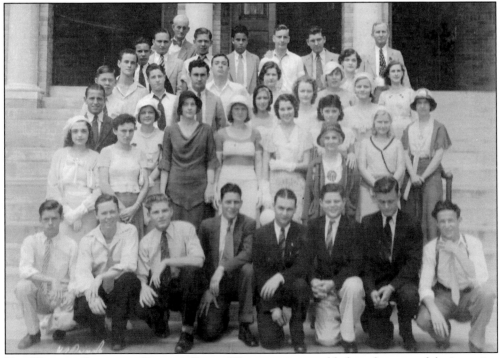

THE HEIGHTS CHRISTIAN CHURCH CHOIR. The group is assembled on the steps of the imposing church for a special Easter service. On the top row at far left is Roy Royall, who managed the Heights substation after John Dunlop became postmaster of the city of Houston. In the fifth row, the man with the boutonnière is Rev. Ed Mace. (HHA.)

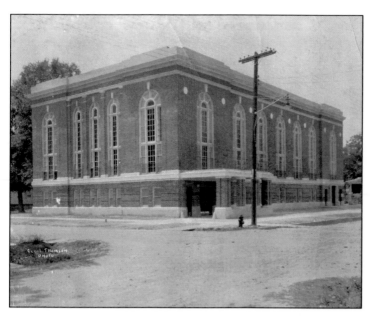

HEIGHTS CHURCH OF CHRIST. Ten people first met in a rented hall at Sixteenth Avenue and Ashland. The only Alfred Finn designed Heights church, this small Neo-Georgian-style church was erected at 120 East Sixteenth Avenue in 1925 with a gift from the Heights' wealthiest citizen, member E. F. Woodward, who lived at 1605 Boulevard in a house Finn also designed. (Courtesy of Heights Church of Christ; NR, LM.)

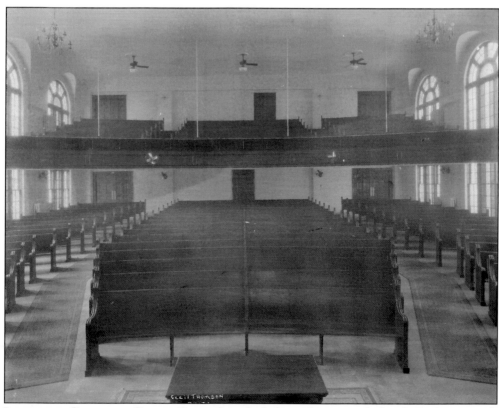

INTERIOR OF CHURCH OF CHRIST. Rows of simple dark wooden pews, the lovely Gothic stained-glass windows on each side, and the graceful electric chandeliers contrast with the necessary fans to provide needed ventilation. (Courtesy of Heights Church of Christ.)

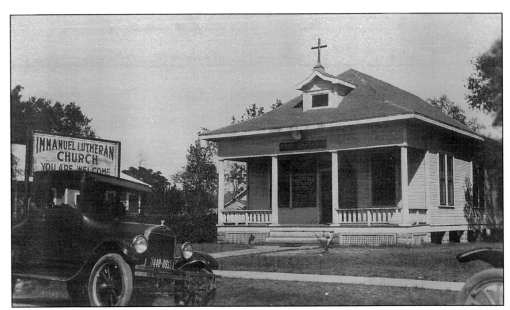

IMMANUEL LUTHERAN CHURCH. A group of 50 Lutherans began conducting church services in 1918 at the Heights High School on Twelfth Avenue and Yale Street. The following year, they purchased this cottage on Allston Street that had served as St. Andrew's first church. The congregation became self-supporting in 1925 and purchased the two lots at East Fifteenth Avenue and Cortlandt Street. (Courtesy of Immanuel Lutheran.)

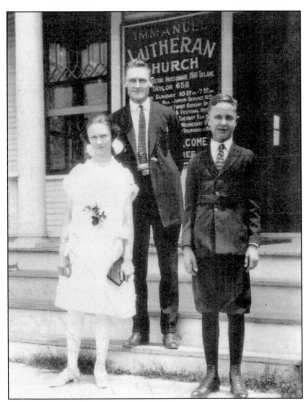

CONFIRMATION CLASS OF 1922.
Pastor William Dietz is standing
in front of 1408 Allston Street
with Dorothy Kleinhaus and
Harry Smith, who have just
been received as new members.
(Courtesy of Immanuel Lutheran.)

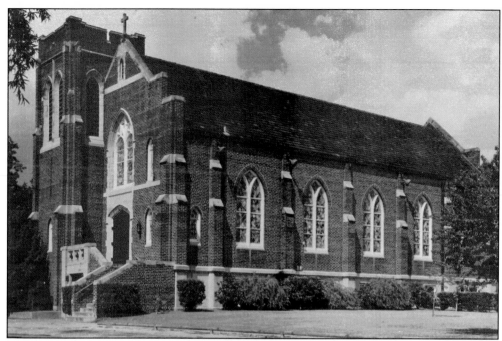

IMMANUEL LUTHERAN CHURCH, SECOND BUILDING. The new church was erected in 1926. The raised basement of the building was used for worship until 1932, when the rest of the building was completed. An angular variation of Gothic architecture, the building is a handsomely finished structure. (Courtesy of Immanuel Lutheran; NR.)

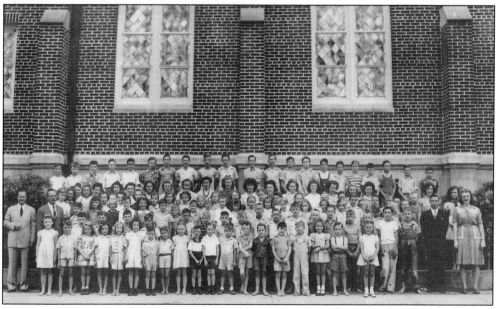

IMMANUEL LUTHERAN SCHOOLCHILDREN. This school picture provides a closer look at the windows in this building. Pastor Elmo Miertschin is standing on the far left with his principal, M. M. Groeschel (right), and a student body largely made up of Heights residents of German descent, including Klebs, Kampraths, Niermeiers, Kerstens, and Hackamacs among others. Immanuel has held a German service at Christmas to celebrate their heritage. (Courtesy of Immanuel Lutheran.)

Four

HOMES

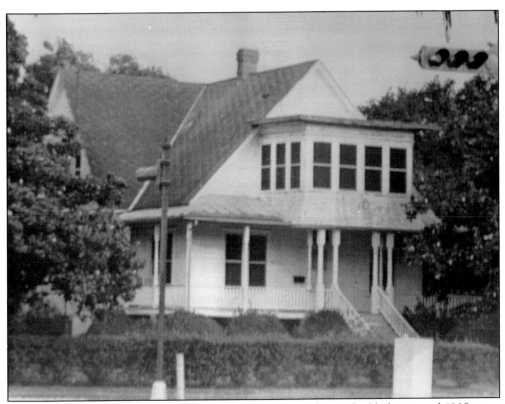

SWILLEY HOME. This house at 1101 Boulevard, constructed on a double lot around 1905, is an example of a high raised Queen Anne. Wealthy real estate investor W. S. Swilley, his wife, Louise Bingle Swilley, and three daughters lived here. The youngest, Louise, never married and died in the house 71 years later. (Courtesy of Swilley family.)

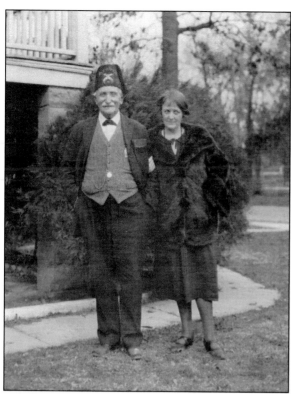

WILLIAM SAMUEL SWILLEY AND LOUISE. Pictured at the side of their house at 1101 Boulevard around 1930 are this Shriner and his daughter. They may have been going to the new lodge on East Eleventh Avenue and Harvard Street. (Courtesy of Swilley family.)

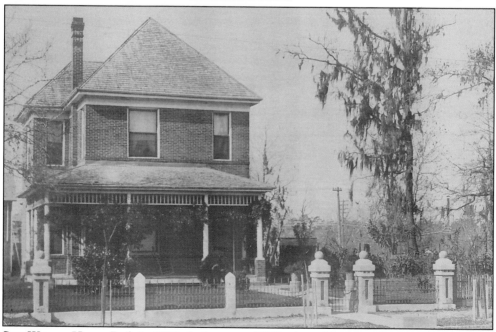

SAM WEBBER HOME. Built in 1902, the home at 407 Boulevard features elements of the Queen Anne style with its asymmetrical plan and wraparound porch. The handsome fencing is gone. Webber, a brick mason, lived here until 1907, when he purchased lots at 1001 Boulevard to build a much larger and finer brick home. (Courtesy of Randy Pace; NR, LM.)

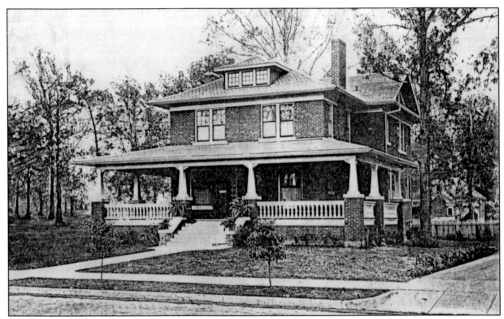

DR. COOP'S HOME. Built around 1910, this Prairie-style brick two-story home at 1536 Boulevard was home to the Coop family. Dr. B. F. Coop, a well-known Heights physician, died in 1930, but his wife remained in the house until her death in 1948. Mrs. Eletha Coop served on the Houston School Board from 1928 to 1942. She also served as president of the Heights Woman's Club and the City Federation of Women's Clubs. (HHA; NR, LM.)

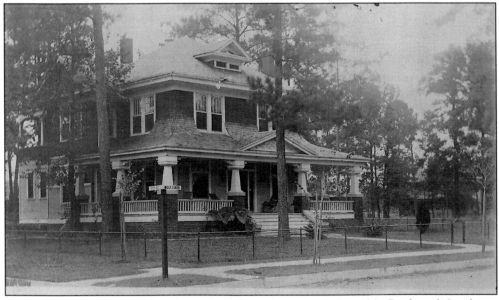

BURGE/SINCLAIR HOME. Robert Burge Sr. built this home in 1910 at 1801 Boulevard. Similar to the Coop home, it is a Prairie-style home with Craftsman and Colonial Revival influences. Burge came from Illinois to open a new branch of his family's showcase manufacturing business, which he operated until his death. His wife, Bessie, then became president and ran the company until 1963. Burge moved from the Heights in 1922, when he sold the house to Dr. Thomas A. Sinclair, who lived there until his death. (Courtesy of Randy Pace; NR, LM.)

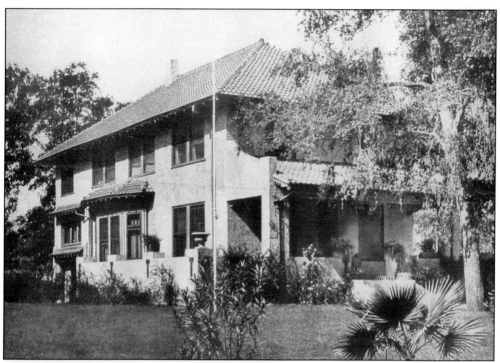

HAWKINS HOUSE. Built in 1911 for George W. Hawkins, the Spanish Revival–style house is located at 1015 Boulevard. Mrs. Nettie Hawkins was president of the ladies' society of her church. Once when she gave a tea, she announced a lovely surprise for guests. The treat was an automobile ride in her Baker Electric. (Courtesy of Thorp family.)

G. W. HAWKINS. The Heights' representative of the automobile industry, Hawkins also had an agency to sell licenses in Harris County. His automobile had Harris County No. 1 license, but after Gov. James Edward Ferguson got an automobile, he decided he wanted No. 1. Hawkins's license became No. 2. During the 1970s, Houston Heights held the "G. W. Hawkins Day" festival, and antique autos paraded up and down the Boulevard. (Courtesy of Thorp family.)

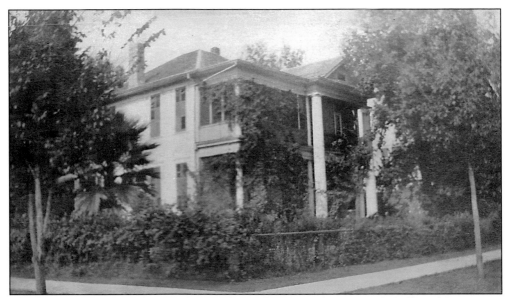

RICHARDSON HOUSE. One of the few Heights area Colonial Revival–style houses, this two-story home was originally located at 1101 Yale Street. Herbert Richardson, listed in the city directory as a carpenter and a contractor, lived here with his wife, Annie E., and his daughter Ethel. In the 1940s, Annie Richardson had the house turned around so that it faced West Eleventh Avenue. (HHA.)

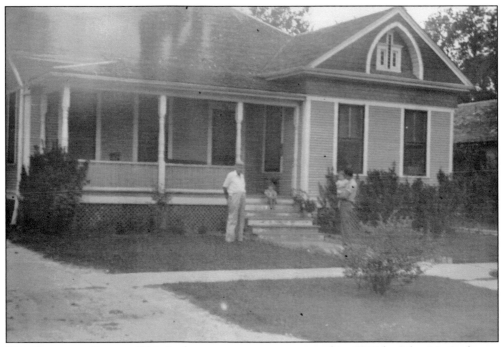

711 COLUMBIA STREET. This L-plan cottage was constructed in 1907 by John M. Anderson on lots purchased from O. M. Carter. A construction superintendent with the Street Building Company in Houston Heights, he built the house himself in stages using lumber left over from jobs. The decorative prominent gable is unusual ornamentation for the neighborhood. (Courtesy of JoEllen Snow; NR, LM.)

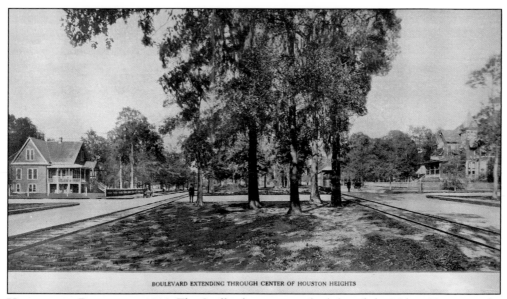

BOULEVARD EXTENDING THROUGH CENTER OF HOUSTON HEIGHTS

VIEW OF THE BOULEVARD 1914. The Swilley house is on the left and the Milroy House on the right. The streetcar tracks border the newly brick-paved Boulevard. Previously, when residents went out at night, they had walked along the car tracks carrying a lantern to see where there were holes. They wore rubber boots and carried their party shoes. Most did not hitch their buggies and take their horses out at night. (HHA.)

242 WEST NINETEENTH AVENUE. Built around 1910, a Baptist Temple minister lived in this American Four Square–style house, purchased by German immigrant Felix Kronberger in 1932. After World War II, he decided to build a commercial strip center, so he had his house moved two blocks to West Seventeenth Avenue. Spectators lined Rutland Street to watch the large home moving slowly down the street on a flatbed trailer. Few houses, if any, were demolished as they could easily be moved. (Courtesy of Kronberger family.)

60

1421 HARVARD STREET. The history of this property indicates speculative buying. In 1896, A. Roberts paid $750 for the lots at 1417, 1419, and 1421 as a gift for his three daughters. They remained undeveloped. In 1905, a man bought all three for only $300 and sold them one day later to developer William A. Wilson for $500. Wilson built this gable-front cottage in 1910 and sold it to Frank Pell, who lived there with his family for many years. (Courtesy of Belinda Ambrose; NR.)

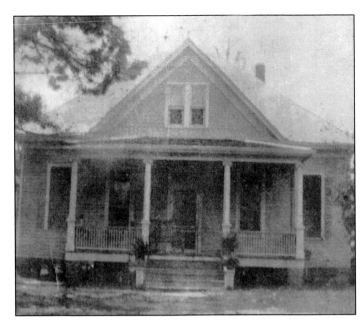

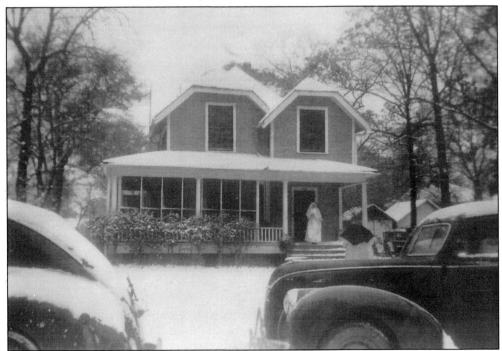

1015 HARVARD STREET. The house, built around 1905, is across the street from All Saints Catholic Church. In 1931, the church bought this home for their schoolteachers, the Dominican Sisters, one of whom is standing on the porch. (Courtesy of Sharon Hattenbach.)

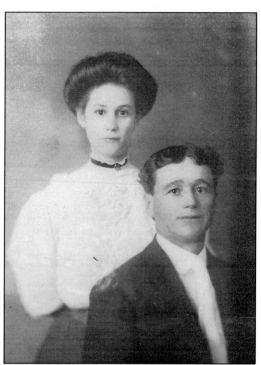

LOUIS AND ANNA HANAGRIFF. The couple, married in Louisiana in 1900, came to Houston Heights in 1909 and moved into their new home at 1115 Yale Street. Louis, a bricklayer, worked on construction of the Galveston seawall and the Scanlan Building. Charter members of All Saints Catholic Church, the childless couple fostered many children. (Courtesy of Amy Lawson.)

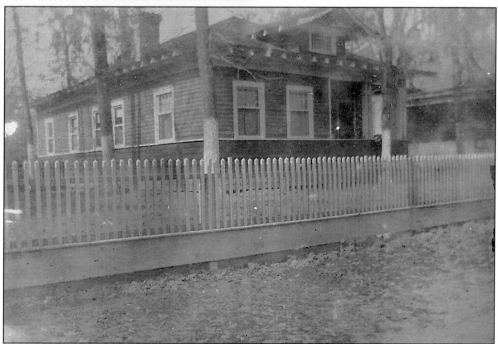

THE HANAGRIFF HOME. A hipped-roof bungalow with the small central dormer is typical of Heights homes. The picket fence was necessary to keep cattle from destroying garden plots and flowers. The controversial livestock restriction law was defeated again in 1911 despite Mr. J. M. Limbocker's editorial, "We have curfews for our children, but not for our cows." (Courtesy of Amy Lawson.)

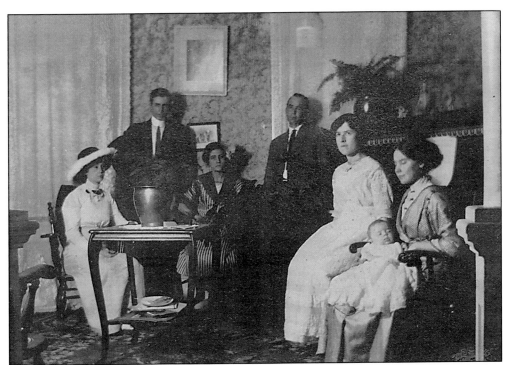

THE HANAGRIFF PARLOR. Anna's parlor was a delightful gathering place for friends. Because they had a piano and the church did not, the All Saints choir practiced there regularly. (Courtesy of Louise Roemer.)

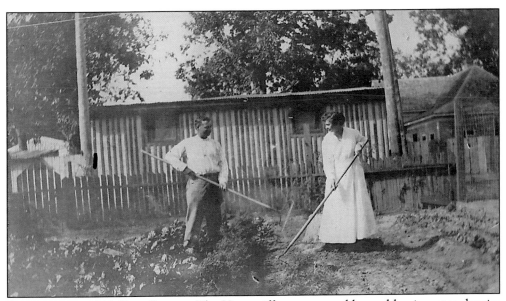

BACKYARD AT 1115 YALE STREET. The Hanagriffs grew vegetables and luscious strawberries in their backyard. The neighboring shed is of board-and-batten construction. (Courtesy of Louise Roemer.)

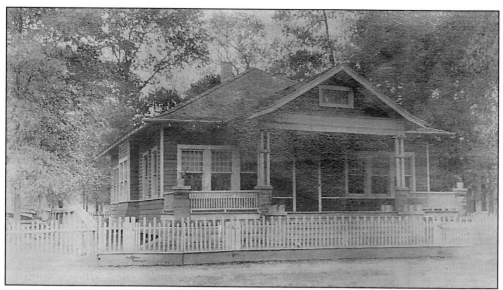

631 Harvard Street. Edwin Mather Wyatt had this home built in 1911. Hired to set up a Manual Training Program at Central High School, he met his bride-to-be at church. Alma Louise Pyles had moved from Iowa to teach school and live with her sister Daisy Sinclair, wife of Dr. Thomas A. Sinclair. When the Wyatts returned from their honeymoon, he proudly carried his wife over the threshold of their new home. (Courtesy of Wyatt family.)

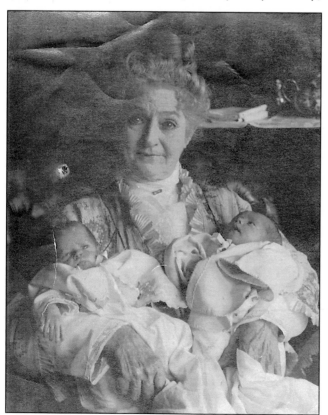

Wyatt Twins. Dr. Sinclair delivered Betty and Bonny Wyatt at 631 Harvard Street on the kitchen table on January 1, 1915. Both girls weighed 6 pounds, and as was customary for twins, they shared a birth certificate. Grandmother Mariah Louise Pyles proudly holds her granddaughters. Wyatt, who read about money to be given for the first twins born in 1915, wrote to Governor Ferguson, who sent him a check for $10. Edwin earned $100 a month, and the money was significant. (Courtesy of Wyatt family.)

THE WYATT FAMILY'S BREAKFAST ROOM.
The cloth-covered breakfast table
positioned in front of the bay window
shows evidence of Christmas activity.
This photograph was taken around
1918. (Courtesy of Wyatt family.)

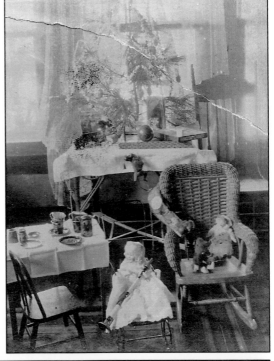

PARLOR AT 631 HARVARD STREET.
The tasseled piano scarf, patterned
carpet, lace curtains, artwork in
elaborate gold frames, and dark velvet
portieres were all typical furnishings
for a late-Victorian parlor. A college
pennant is displayed, perhaps, as
evidence of the couple's higher
education. (Courtesy of Wyatt family.)

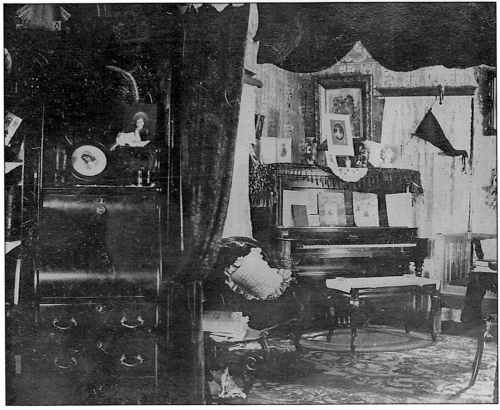

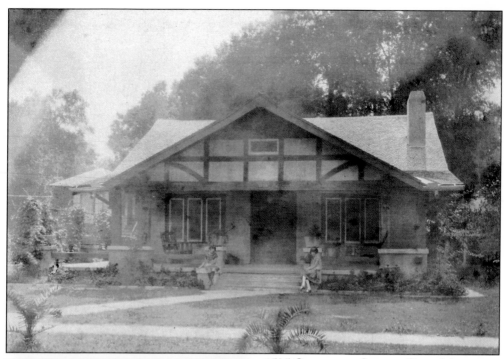

1525 CORTLANDT STREET. One of the most prominent Craftsman bungalows in the Heights, this home was built in 1911 for H. O. Westwood. The builder of the house was obviously influenced by the California Craftsman style with its Tudor half-timbering ornamentation. (Courtesy of Nora Dobin; NR, LM.)

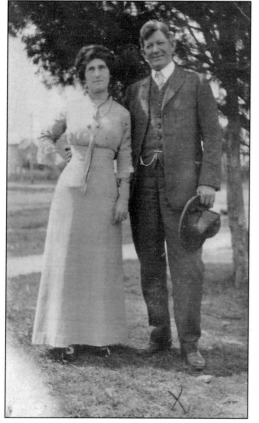

MR. AND MRS. D. A. SMITH. Frances, or Nonie as she was called, and her husband, David A. Smith, moved to 1525 Cortlandt Street in 1922 where they lived for 22 years and reared their three sons. (Courtesy of Nora Dobin.)

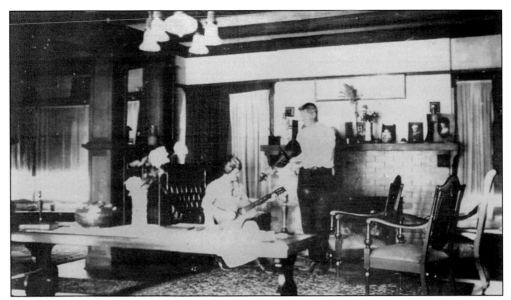

INTERIOR OF 1525 CORTLANDT. This view illustrates the open concept of Craftsman homes. The 29-foot-long living/dining area features a colonnade separating the rooms that also have beamed, coffered ceilings. The two musicians playing a guitar and a violin are performing in front of the fireplace. The hammered-metal light fixture resembles designs in Stickley's catalogs, as do the sconces flanking the mantel. (Courtesy of Nora Dobin.)

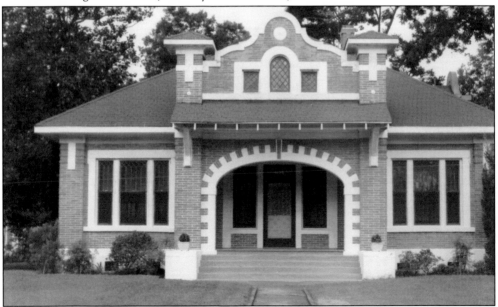

1123 HARVARD STREET. Known locally as the "Alamo" house, this mission/Spanish Colonial–style bungalow is the most elaborate and unique of its kind in the city of Houston. It was built in 1912 by bricklayer Joseph Schleser for his bride and is a true brick load-bearing structure. The Burrows family lived there from 1937 to 1997. When they moved in, the house had two electric outlets, one in the living room and one where the built-in ironing board came down. The Burrows replaced the hand pump that removed water from the basement during heavy rains with an electric model. (Courtesy of R. C. Burrows; NR, LM.)

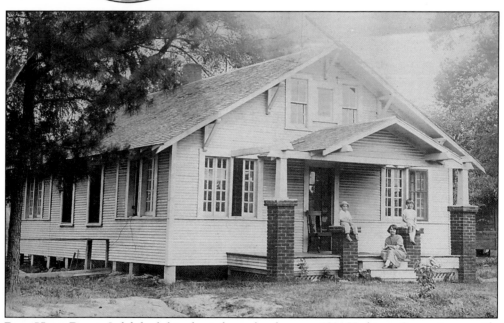

LELAH POLK. Lelah Johnston had already graduated from Chicago Institute of Art when she met and married Lucius Rivers Polk in 1912. They met in Illinois, where Lucius, a telegraph operator for Southern Pacific Railroad, had traveled. He brought her back to Houston Heights but continued traveling with the railroad. Lelah, when not caring for the four children born of the marriage, busied herself by buying lots and building Heights spec houses. (Courtesy of George Polk Jr.)

POLK HOME PLACE. Lelah had this classic bungalow home at 1324 Herkimer Street, just outside Houston Heights city limits, built for her family in 1921. George Polk Sr. was born here, and when he married, he moved back in and reared his family. George Polk Jr. remembers, "The street was sand, and you couldn't ride a bicycle so my father bought me a horse in 1948 to ride to school." (Courtesy of George Polk Jr.)

FREET HOME. Archie Lee Freet operated his plumbing company in the garage behind this white stucco bungalow at 1239 Yale Street. The painted columns with the Craftsman detailing pleasantly contrast with the porch's red-brick trim. Archie, Hattie, and their daughters Cleo and Thelma had previously lived at 1305 Yale Street in a late-Victorian-era cottage that is now utilized as part of the McDougall Sewing Machine Company. (HHA.)

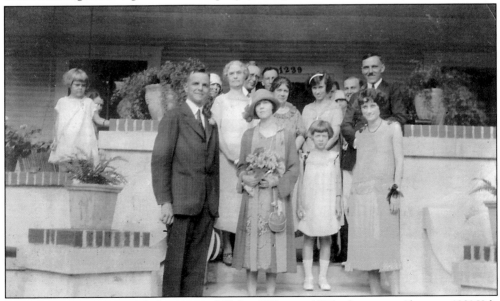

FREET/WILSON WEDDING. Thelma married Clifton Wilson in 1925 at her parents' home at 1239 Yale Street. The bride, who had had aspirations to be a musician, was now working as a stenographer. Her street dress, matching coat, small bouquet, and pocketbook are typical of Heights weddings during the 1920s. (HHA.)

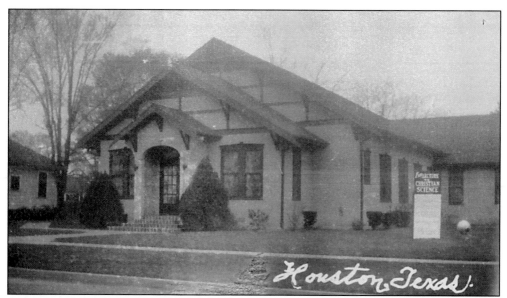

A Church Becomes Two Homes. The Second Church of Christ Scientist was organized in 1919. This stucco church at East Fourteenth Avenue and Harvard Street was completed in 1920. The larger church sanctuary facing Harvard was completed in 1930. The church sold the property in 1996 to a developer who moved the north wing to 1416 Harvard Street, converting it into a residence. He then adapted the remaining building into another residence as it exists today. (Courtesy of Randy Pace.)

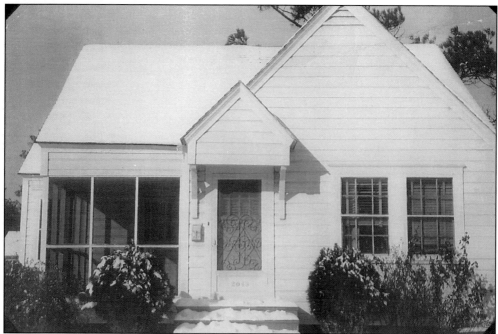

Dockal's Home. Doris Dockal's aunt left her $3,000, just enough money to have this home built in 1940. Located at 2043 Columbia Street, the English bungalow was one of the first houses on the block. As was common in earlier times, the family of six lived in this 1447-square-foot home with only one bathroom. (Courtesy of Dockal family.)

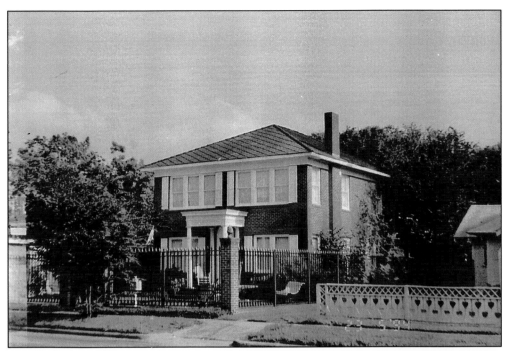

THE T. C. JESTER/CLAYTON LEE HOME. The brick home at 317 West Twentieth Avenue was built in 1928 for Rev. and Mrs. T. C. Jester (Mae). The building contractor was W. L. Goyen, and Clayton Lee was the plumbing contractor. The Jesters lived here until 1958, when Lee purchased the home. (Courtesy of Libby Lee.)

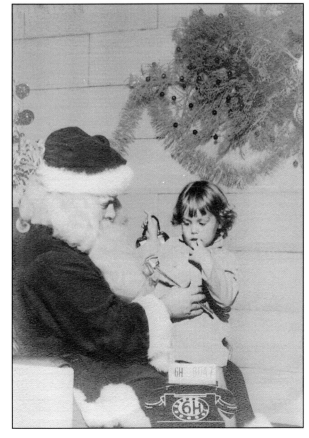

JANE JESTER MARMION. The granddaughter of T. C. Jester and the future wife of J. B. Marmion's grandson, Jane is pictured with Santa in 1947. Jane remembers her childhood spent exploring the wonders of her grandparents' home, shown above. Holidays and birthdays were all celebrated at 317 West Twentieth Avenue. (Courtesy of Jane Marmion.)

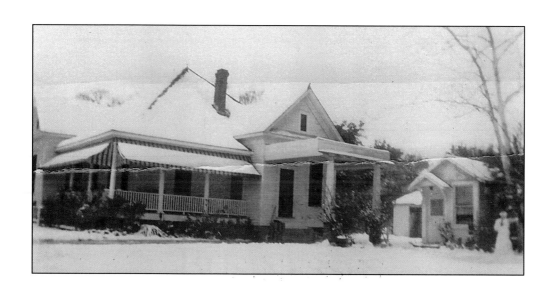

HOUSTON HEIGHTS IN THE SNOW. On January 22, 1940, Houston received an unprecedented 3 inches of snow, causing all Kodak owners to get out their cameras to record the occurrence. Pictured above is a side view of Joseph and Minnie Blazek's home, built in 1907 at 319 West Fifteenth Avenue. Joseph Blazek was secretary-treasurer of the Wald Transfer and Storage Company. They lived here with their three children. The photograph below is of Judge James G. Donovan's home. Donovan had this Four Square–style home built in 1919 at 1225 Boulevard. Remembering the damage inflicted by the 1915 hurricane, the judge had the builder put 6-foot steel bolts through the piers underneath the home. John Pollack, a well-respected Heights contractor who lived at 625 East Tenth Avenue, built the home. Situated on a double lot, the house had outbuildings for their cow and chickens. (Above courtesy of Blazek family; below courtesy of Gayle Saunders.)

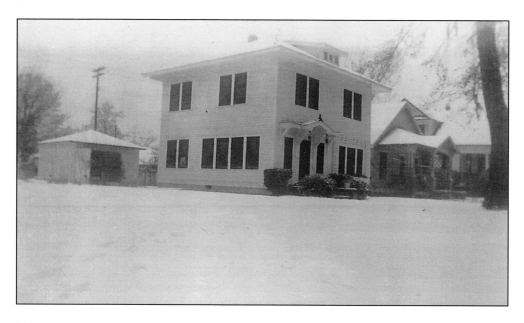

Five

BUSINESSES

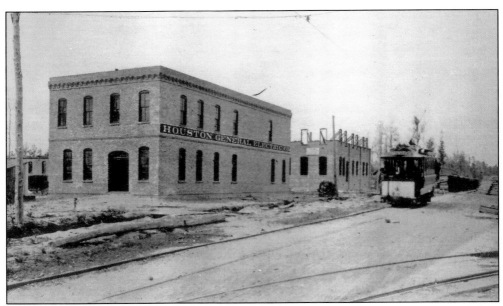

HOUSTON GENERAL ELECTRIC COMPANY. The company, organized in 1892, erected this substantial brick building (now demolished) soon after. The streetcar is making its run south on Railroad Street (Nicholson) in the northwestern section that Carter designated for industries where the streetcars shared freight railroad tracks. Though the business was incorporated on May 5, 1893, the entire Heights area did not receive electrical service until 1905. (HMRC.)

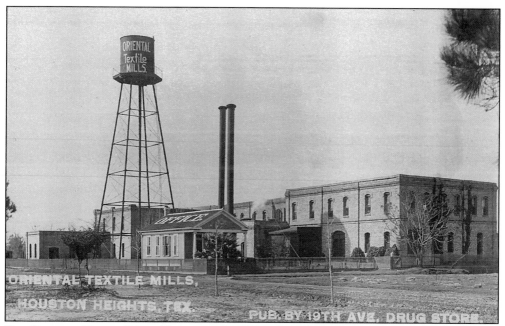

THE ORIENTAL TEXTILE MILL. Constructed in 1894, the plant had several owners but is generally known as the Textile Mill, located on West Twenty-second Avenue and Lawrence Street. The owners built small frame cottages for the workers one block north of the plant. Smaller blocks were platted in this area for exactly this purpose. (Courtesy of Randy Pace.)

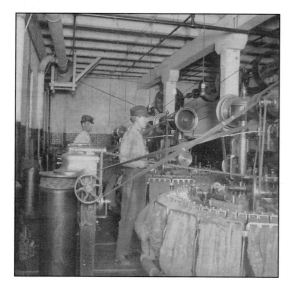

INTERIOR OF ORIENTAL TEXTILE MILL. As the photograph shows, real hair was used to give strength to the textiles that were manufactured, whether Chinese pigtails as older residents claimed or camel hair. The shown workers at the loom included Earnest Stitston (front) and an unidentified man, but another work crew consisted of children. Eight-year-old Senfronia Pritchett was put to work as a bobbin girl in 1900. They stood her on a box so she could reach the equipment. When federal authorities came by, the youngsters were whisked out of sight. She worked six days a week, 10 hours a day, and made $3.50 a week. She lived with her family in the "Textile village." (Courtesy of Randy Pace.)

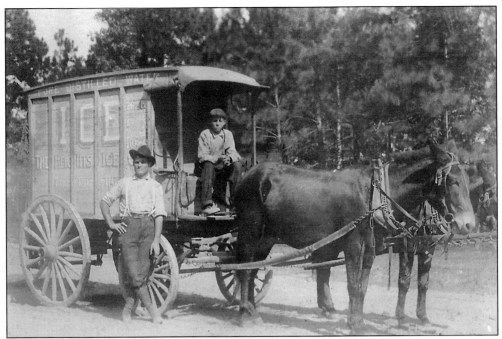

THE HEIGHTS ICE WAGON. Ice wagons were a familiar sight in the age before refrigeration. Housewives had a card that they displayed in the window to show how many pounds of ice to deliver. (Courtesy of Roger Synott.)

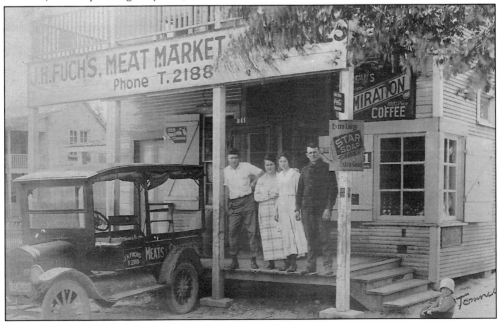

FUCHS MEAT MARKET. Located at 841 Tulane Street, this market was owned by John and Gertrude Fuchs. Pictured on the porch of the store are, from left to right, the delivery man Cecil Jones, owner Gertrude Fuchs, Velma Hitchcock, a saleslady, and Ed Fuchs, the butcher. A neighborhood child named Tommy is on the ground. The family lived on the second floor of the building, now demolished. (Courtesy of Rita Donaldson.)

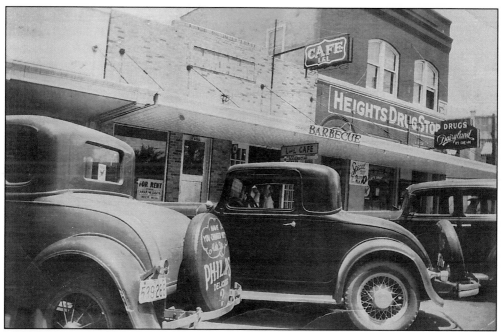

L&L Café. Located on the north side of the 400 block of West Nineteenth Avenue, Sammie Donaldson's first diner (now demolished) opened in 1930. The intersection of Nineteenth Avenue and Ashland Street was the heart of Houston Heights' commercial district. To the right of L&L was the Heights Drug Store that would later become Mading's Drug Store. (Courtesy of Rita Donaldson.)

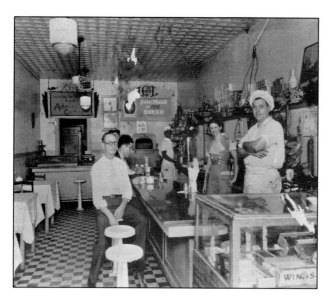

Interior of L&L Café. Sammie Leslie Donaldson was employed by Houston Electric Company. His friend and employee Lewis Cook was his cook. Lewis is wearing the white hat and apron. The name of the café was an abbreviation of the names of the owner and the cook, Leslie and Lewis. Sammie's wife, Myrtle Fuchs Donaldson, daughter of the Fuchses who owned the meat market on Tulane Street, also helped in the café. Breakfast specials were "Ham/Bacon & Eggs" for 25¢ or any kind of cereal with "pure" cream for 15¢. (Courtesy of Rita Donaldson.)

CITIZENS STATE BANK. The imposing neoclassical building at 3620 Washington Avenue, designed by Joseph Finger in 1925, housed Citizens State Bank until 1946, when it became Heights State Bank. The building made an impressive entrance to the Heights community. (Courtesy of Story Sloane.)

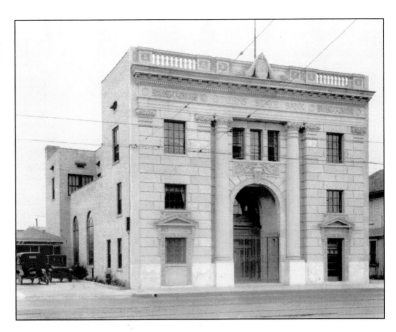

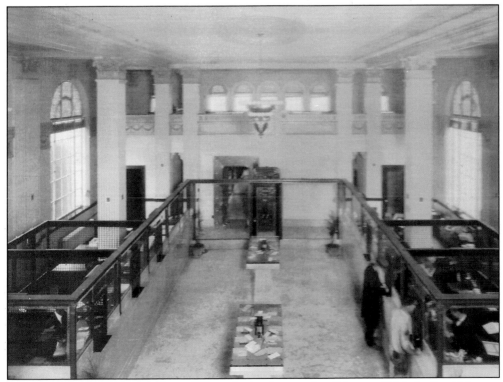

INTERIOR OF CITIZENS STATE BANK. When this bank opened in February 1926, the furnishings—stainless steel vault pictured at the far end, arched side windows, and matching smaller windows above the vault—were the most modern and ornamental of that time. Today the space is occupied by Rockefeller's. (Courtesy of Hugh Blazek.)

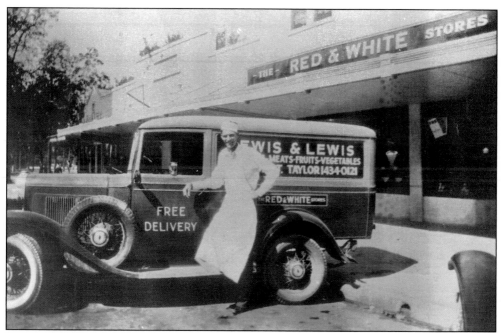

LEWIS AND LEWIS GROCERY. An unidentified driver is pictured in the front of the Lewis brothers' Red and White grocery. Joe Lewis was the owner of much of the property in the commercial district of Houston Heights and was a director of Reagan State Bank. (HHA.)

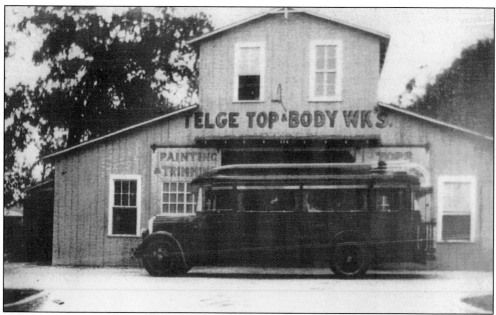

TELGE TOP AND BODY WORKS. Mr. W. F. Telge opened his garage at 121 Boulevard in the 1920s. Many Model Ts had cloth tops made of heavy canvas. When this cloth tore, repairs were necessary. If Telge had no garage work, he built boats. One of these boats was purchased by the Federal Liquor Control Board during Prohibition and used to patrol San Jacinto River for bootleggers. Heights Station Antiques has occupied the building since 1977. (Courtesy of Sharon Hattenbach.)

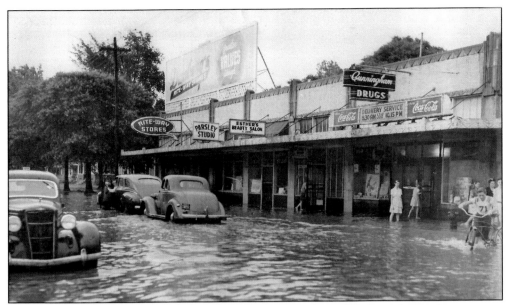

CUNNINGHAM DRUGS. The art deco–style strip center, built in 1931, is on the northeast corner of Yale Street and Fifteenth Avenue. W. O. Cunningham bought the drugstore in 1932 from Mading's. By 1954, he and his son Max, now a graduate pharmacist, were using all but the end space. Cunningham sold the store in 1975. Mr. August Danburg, owner of Rite-Way Stores, changed the name of his chain to Globe Discount Stores. The street flooding occurred in 1945. (Courtesy of Cunningham family.)

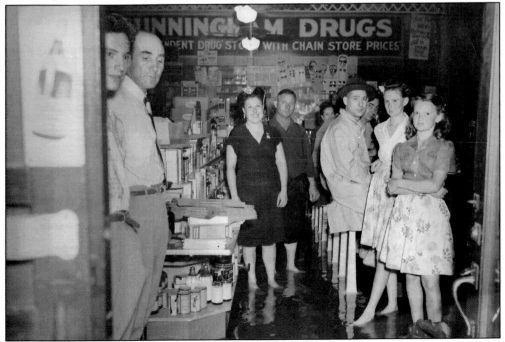

INTERIOR OF CUNNINGHAM DRUGS. The flooding shown above had penetrated the store's interior. W. O. Cunningham (pictured on the left wearing a white shirt and tie) seems disgusted, but the patrons at the fountain are unperturbed. (Courtesy of Cunningham family.)

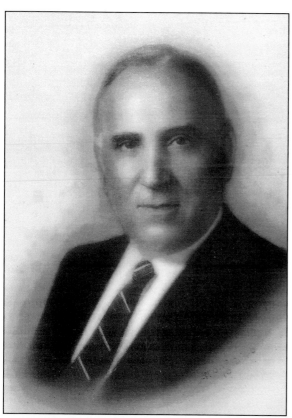

DR. THOMAS A. SINCLAIR. Born in Iowa in 1873, he graduated from medical college there in 1905 and came to Houston Heights in 1907 to be the house physician at the Texas Christian Sanitarium. In 1909, he went into private practice in a second-floor space at Fulton's Drug Store on West Nineteenth Avenue. A friendly, popular civic and church leader, Sinclair practiced medicine until his death in 1940, delivering thousands of Heights babies. After his death, his wife, Daisy Pyles Sinclair, became president of the board of directors and helped run the hospital. (Courtesy of Ann Cox Hall.)

HEIGHTS HOSPITAL. By 1943, the small Heights Clinic Dr. Sinclair had founded 19 years before occupied a large portion of the 1900 block of Ashland Street. This facility was an important part of the community. Sinclair Elementary was named after Thomas Sinclair. (Courtesy of Parsley Studio.)

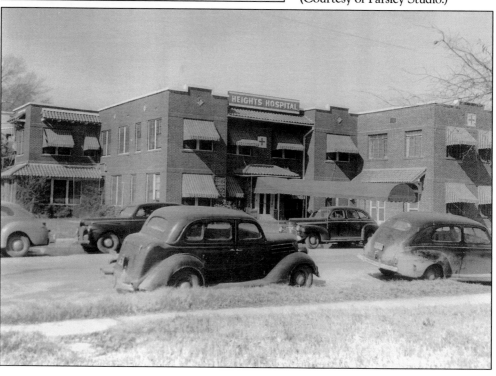

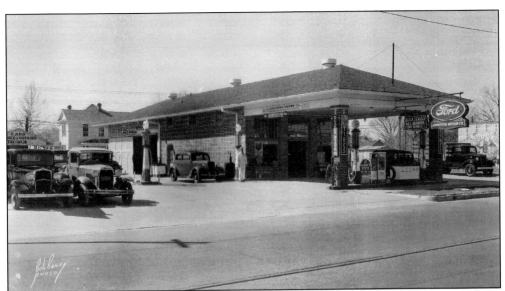

JOHNSTON MOTOR COMPANY. This 1935 photograph of an early Heights Ford dealership (now demolished), located at 330 West Nineteenth Avenue, was in the heart of Houston Heights' commercial district. Simon Johnston and his family resided in the home shown in the background, 333 West Eighteenth Avenue. Obviously, Johnson could not depend on automobile sales alone, and his signs indicate his speedy repairs and washing and "greasing" of cars. (Courtesy of George Polk and the University of Texas at Austin.)

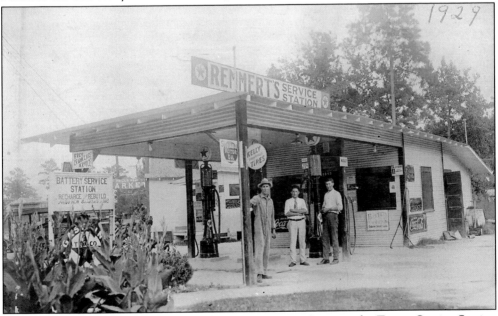

REMMERT'S SERVICE STATION. In 1929, Herbert Remmert Sr. opened a Texaco Service Station located at Sixteenth Avenue and Columbia Street. Herbert and his wife, Olga, lived across the street at 501 East Sixteenth Avenue, but he died young. Olga, left with a son to rear and a service station to run, went into partnership with her father-in-law. When her son was grown, he took over the business, which is now run by his sons. This third-generation Heights business is now Remmert Automotive Service, an old established Heights business. (Courtesy of Remmert family.)

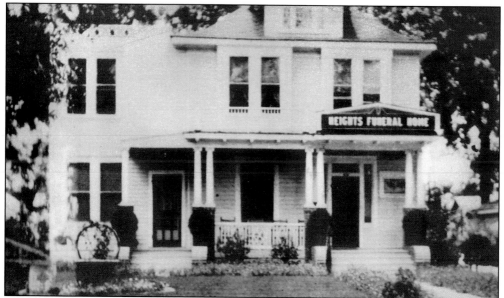

HEIGHTS FUNERAL HOME. Robert E. Waltrip, son of educator S. P. Waltrip, received his funeral director's license shortly after graduation from Heights High. He bought Heights Funeral Home in 1926, and the Waltrip family moved into the space above. His father continued as school principal, and his mother, Hattye, became his business partner. The first service they performed was for the family of a stillborn child. Hattye took the infant upstairs into their living quarters and stayed with the stillborn child all night. Developing a reputation for sensitivity and individual service, Robert became active in Heights organizations, and the prominent families of the Heights began using his services. When he died at 48, his son Bobby was only 20, and the business was financially in trouble. Robert's widow, Wanda, earned her funeral director's license in 1953, and for the second time in the company's history, a woman occupied a major role. Wanda Waltrip, a hardworking well-respected businesswoman, turned the business around. The current structure was dedicated in 1958 with Mayor Louis Cutrer and Congressman Albert Thomas officiating. Wanda's son later founded SCI, an international conglomerate that dominates the funeral industry today. (Courtesy of Bob Waltrip.)

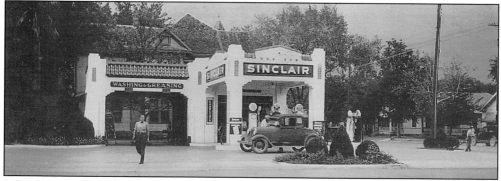

J. B. MARMION SERVICE STATION. Marmion's first service station (1933–1949) was on the northwest corner of West Nineteenth Avenue and Yale Street. He moved his business to the northeast corner and built a larger station that he operated until his retirement in 1969. Recently, this property was redeveloped, and the environmental testing revealed a full underground gas tank left from Marmion's second station. The tank was still intact, had not leaked, and was safely emptied. (Courtesy of Marjory Griffiths.)

PIELOP AUTOMOBILE REPAIR SHOP.
William Ernest Pielop lived in a frame
bungalow at 615 West Nineteenth
Avenue. Behind his house, he ran
this repair shop (demolished) that was
constructed of ashlar blocks, called
the stone "with faces." Pictured is an
unidentified customer posing with an
umbrella. (Courtesy of Bill Pielop.)

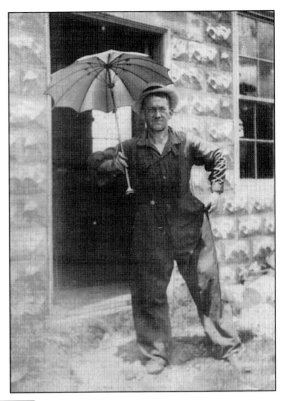

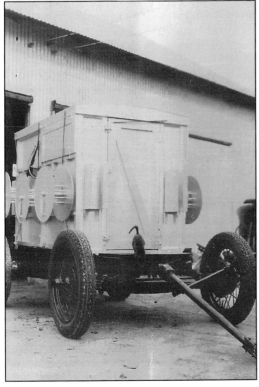

PIELOP WAGON. William Pielop
manufactured this wagon around 1920
in the large tin shed pictured in the
background, indicating his automobile
repair shop had advanced to a new level.
In 1940, he would found National Flame
and Forge as an outgrowth of this backyard
machine and repair shop. Today the
company is a third-generation production
facility occupying 400,000 square feet
and is located at 330 West Twenty-fifth
Avenue. (Courtesy of Bill Pielop.)

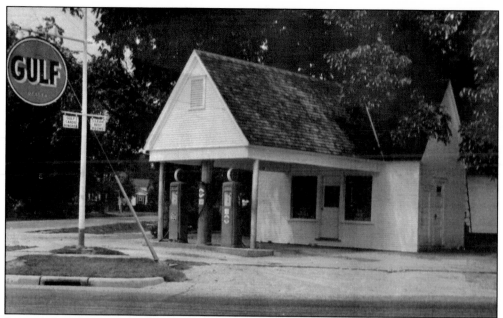

SCHAUER'S GULF STATION. When Fred Schauer opened his English cottage–style station at 1402 Oxford Street in 1929, gasoline sold for 10¢ a gallon. Fred married Hazel Farris and moved next door to 607 East Fourteenth Avenue, a house made of apple crates put together with square nails. In his heyday, Fred sold more gasoline than any other Gulf station in Texas, Oklahoma, and New Mexico. (Courtesy of Schauer/Davis family; NR.)

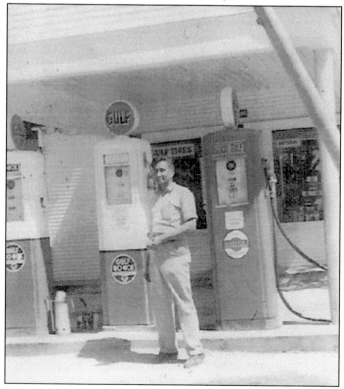

FRED SCHAUER. Operating a business from 1929 to 1978 required commitment to customer care, and Fred Schauer knew this. He greeted his customers, who were friends and neighbors, with a dimpled smile, unconsciously whistling or singing from morning until night. When a customer drove up to the station, Fred would yell, "Car, car, car!" to his men. He had around 800 customers and, amazingly, had memorized their seven-digit credit cards. (Courtesy of Schauer/Davis family.)

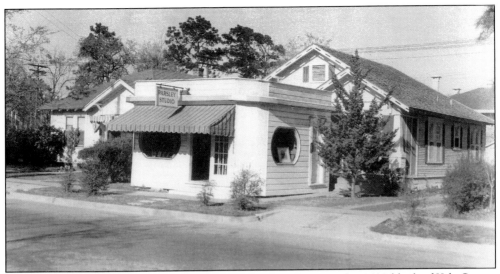

PARSLEY STUDIO. The business was established in May 1942 in the 1600 block of Yale Street. The family rented the house to the left of the small studio. Using the screened-in porch, Mr. Howard Parsley put up boards to make a darkroom. He developed negatives in the family bathtub since the studio had no plumbing. One year later, the Parsleys moved to 1504 Yale Street, where they have been for over 60 years. Mrs. Louise Parsley and her daughter continue to operate the business. (Parsley Studio.)

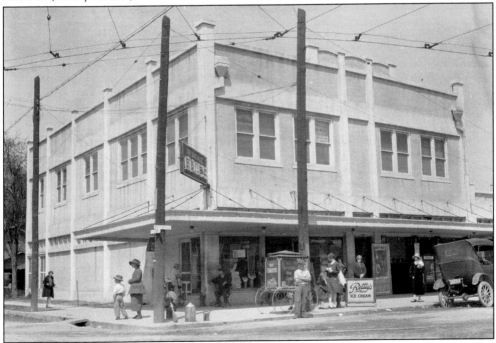

WARD'S PHARMACY. In 1926, Simon Lewis, owner of the buildings at 375–355 West Nineteenth Avenue, leased the space to Maurice Ward, and his family lived upstairs. This was the original site of the Houston Heights Hotel. M. T. Ward prepared all of the prescriptions himself. His wife, Ella, was a nurse at Heights Hospital. The popular deli Carter and Cooley has occupied the space since 1995. (Courtesy of Story Sloane.)

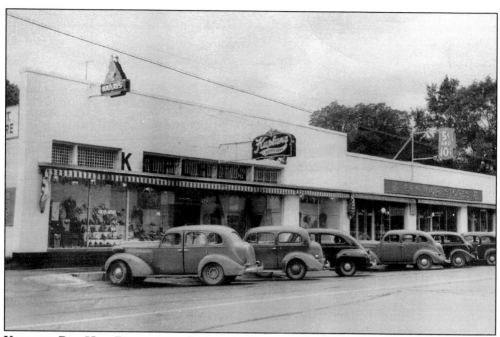

KAPLANS–BEN HUR DEPARTMENT STORE. As Houston Heights prospered, so did the Kaplan family. The photograph taken just after World War II helps explain the unusual name of the establishment. Dave Kaplan, who began the store in 1913, had two sons, Bennett and Herman. When both insisted on coming into the business, their father helped them open a five and dime as shown above, naming it an abbreviation of their own names. Clayton Lee called this store the "Neiman-Marcus" of Houston Heights. Because of their business integrity, the store became a beloved institution, gradually expanding to cover almost two blocks at Twenty-second Avenue and Yale Street. Sadly, the business closed in 2006, and the building is demolished. (Courtesy of Martin Kaplan.)

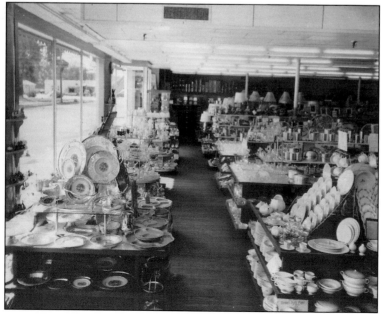

CHINA AND CRYSTAL. After the wedding date was set, Heights brides went to Kaplan's to register. They were ably assisted by the employees, some of whom worked there for 40 years. Beautiful, glossy Christmas gift catalogs were mailed citywide to 285,000 residents. Fueled by the vision of Bennett's wife, Dorothy, the store served all of Greater Houston. (Courtesy of Martin Kaplan.)

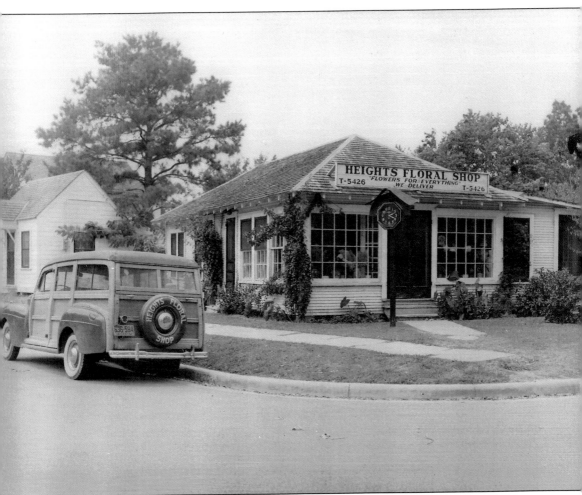

HEIGHTS FLORAL SHOP. In 1953, Wallace and Bonny Wyatt Nobles purchased this floral business. This building had originally faced Ashland, but the entrance was changed to face West Twentieth Avenue. Bonny Nobles was Dr. T. A. Sinclair's niece, and the flower shop became closely associated with the medical facility. Wallace, an active member of the Texas State Floral Association, served as president in 1957. The station wagon known as "the Woody" was used for deliveries. During the 1950s, their Floral Telegraph Delivery orders came over a ticker tape, and the average order was $2.50. Bonny, one of the Wyatt twins born in 1915 at 631 Harvard Street, worked in the store until her death at age 90. The building above was replaced in 1984, and the business continues, run by their son Wally Nobles. (Courtesy of Nobles family.)

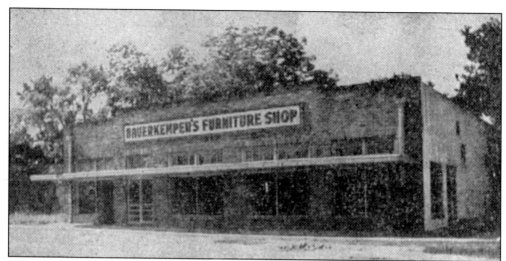

BAUERKEMPER FURNITURE SHOP. William and Emma Bauerkemper operated this business at 521 East Sixteenth Avenue for over 45 years. Though his furniture shop was twice destroyed by fire, Bauerkemper rebuilt it. Also housed in this building was Olaf Birkelbach's Barber Shop. Patrons remember the Coke machine, a Vendo 23 "spin top." Also remembered is the constant polka music played on radio station KFRD, broadcasting from Rosenberg. (Courtesy of Bauerkemper family.)

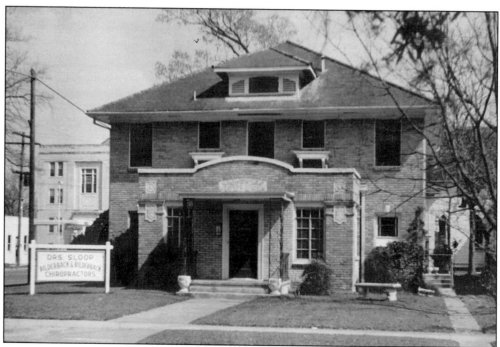

SLOOP AND BILDERBACK. Hiram Sloop, a well-established Heights chiropractor, built the building at 1050 Boulevard in 1929. He expanded the practice in 1949 to include his daughter and her husband, Carrie and "Woody" Bilderback. After Hiram's death, the practice continued as Bilderback and Bilderback for the next 30 years. The practice, now operated by Dr. Brian Hawkins, is the oldest continuous chiropractic location in the state of Texas. The Masonic Lodge at Harvard Street and Eleventh Avenue is seen in the background. (Courtesy of Carrie Sloop Bilderback.)

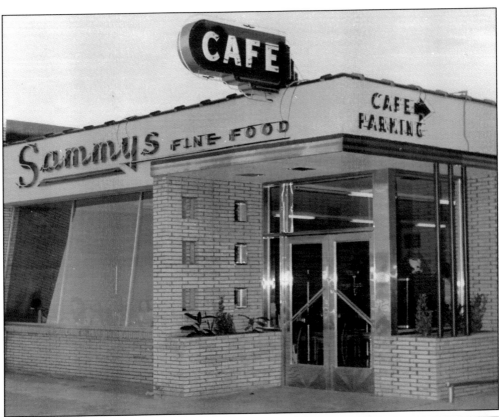

SAMMY'S CAFÉ. Sammy Donaldson opened his third café at 344 West Nineteenth Avenue in 1951. This restaurant (now demolished) provided parking and a modern 1950s exterior. The newspaper announced the return of Sammy's "famous fine foods." Brother Jester had an arrangement with Sammy, who was one of his congregation. If Jester brought in someone for a cup of coffee, he would not be charged. Sammy considered this a donation to his church. (Courtesy of Rita Donaldson.)

Breakfast Menu

Served All Hours

ORANGE JUICE	.15
TOMATO JUICE	.10
GRAPEFRUIT JUICE	.10
COTTAGE CHEESE with Cream	.35
OATMEAL OR DRY CEREALS with Rich Cream	.35
RAISIN TOAST	.20
TOAST, State Preference of Whole Wheat or White Bread	.15
OUR SPECIALTY — 2 Eggs, Scrambled with Toast	.35
HAM, BACON OR SAUSAGE and EGGS	.65
WAFFLES with Maple Syrup	.35
GRIDDLE CAKES	.35
SWEET ROLL	.10
DONUT	.05

SAMMY'S CAFE
FINE FOODS
344 West Nineteenth

SAMMY'S MENU. The first page of the menu with its breakfast list indicates the reasonable prices, which accounted for part of his success. (Courtesy of Rita Donaldson.)

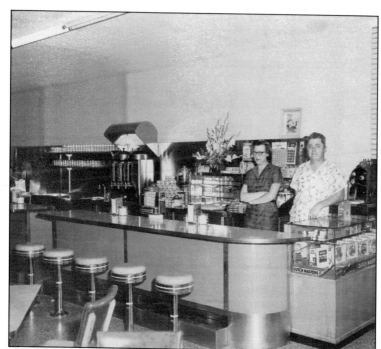

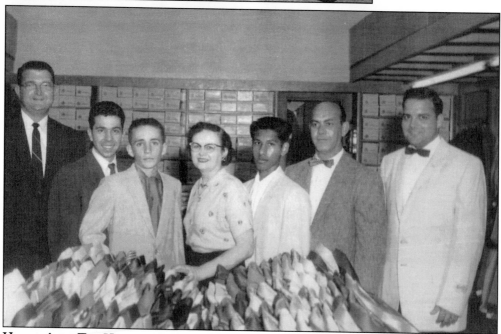

HAROLD'S IN THE HEIGHTS. In 1950, Emmanuel Wiesenthal and his two sons founded this menswear store at 350 West Nineteenth Avenue. The original 1,200-square-foot store was expanded to include the site of adjacent Sammy's Café in 1980. Offering fine men's and women's apparel, Harold's has an elite and dedicated following among Heights residents, national celebrities, and professional athletes, especially golfers. This 1953 photograph shows, from left to right, Milton Wiesenthal, Leonard Tritico, Richard Davenport, Viola Holloway, Arthur Medina, Tony Debecky, and Harold Wiesenthal. (Courtesy of Harold Wiesenthal.)

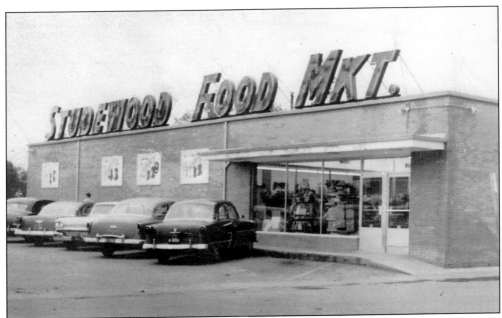

STUDEWOOD FOOD MARKET. Melvalene and Carl Cohen purchased an existing store in 1950 at West Fourteenth Avenue and Studewood Street. By the late 1950s, they had replaced the original building with this 15,500-square-foot store. Shrewd purchasing, private branding, and services that included payroll check cashing, a snack bar, and an in-store pharmacy contributed to their success. Promotions such as Easter egg hunts, dog costume contests, Santa Claus visits, and appearances by popular country singers Don Mahoney and Jeanna Clare added to the store's popularity. (Courtesy of Melvalene Cohen.)

MELVALENE COHEN. Always in the store, ready to greet customers and keeping a watchful eye on the business operation, Melvalene is pictured in 1957 next to a candy exhibit. (Courtesy of Melvalene Cohen.)

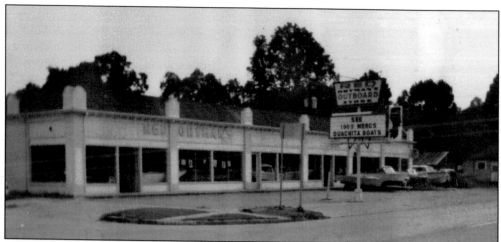

RED ORTMAN'S OUTBOARD MOTORS. Red-headed Ortman came to Houston after World War II and trained as an outboard motor mechanic at Western Auto. He started his own business in 1954 and in 1965 moved to this 1928 building that had housed a furniture store. Nine years after Ortman's closed, Sharon Ortman Kopriva, who now operates Redbud Gallery in this location, says occasionally a car pulling a trailer with a boat still drives up in front expecting help. (Courtesy of Sharon Kopriva.)

DAVIS HARDWARE. Robert Davis opened this "hardware" store at the edge of the Heights in 1956. The photograph above shows the original location at 1021 Studewood Street. It is family-owned and operated, and the third generation is already trained to offer the same pleasant, knowledgeable service as their grandparents Robert and Sherry did. Davis converted his store to a custom frame shop and art gallery some years ago. Artists and patrons come from all over Houston to select their frames at this popular Heights business, although some Heights newcomers still think the store sells hardware. (Courtesy of Davis family.)

Six

PEOPLE AND CLUBS

HELEN GRACE WINFIELD. The young Winfield is pictured at home in New York prior to her marriage to Daniel Denton Cooley in 1883. The couple and their three sons moved into their new home at 1802 Boulevard in 1893. The 1896 *Blue Book* of Houston noted, "Mr. and Mrs. D. D. Cooley are at home to visitors on Thursdays." (Courtesy of Talbot Cooley.)

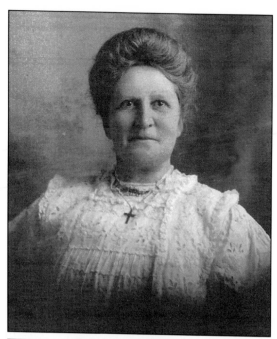

HELEN WINFIELD COOLEY. During her marriage to D. D. Cooley, he gifted her with many lots in Houston Heights on special occasions, such as birthdays and anniversaries. Helen Cooley generously gave Lot 25, Block 105 to the Houston Heights Woman's Club in 1911 so that the members could have a clubhouse built. A charter member and president, she was very active in the club. An oil painting of this photograph hangs in the clubhouse today. (Courtesy of Talbot Cooley.)

HOUSTON HEIGHTS WOMAN'S CLUB. On January 15, 1900, sixteen women of Houston Heights formed a literary club. By 1909, the group, too large to meet in homes, used a room in O. M. Carter's power plant until Helen Cooley's gift of a lot enabled them to build a clubhouse. In February 1911, the literary club became the Houston Heights Woman's Club. The women borrowed $1,200 to build this house that opened in October 1912, remarkable since they did not even have the right to vote. The stage had to be lowered twice because it showed the ladies' ankles. For 97 years, the club has met here. If the walls could talk, the clubhouse would recall the hundreds of Heights functions held here over the years: high school and junior high dances, graduation parties, Scout functions, and business and church meetings. (HHA; NR, LM.)

IRENE UPCHURCH BORGSTROM.
Irene resided at 301 East Fourteenth
Avenue. Graduating from Heights
High in 1911, she worked for
Missouri Pacific Railroad for the
next three decades. During World
War I, she sang for the troops at
Camp Logan. In 1920, she married
Emil Borgstrom and moved across
the street to 1401 Cortlandt Street,
where she lived until her death.
An accomplished seamstress, she
made this dress for her graduation.
(Courtesy of Upchurch family.)

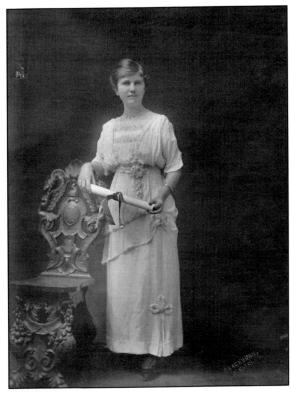

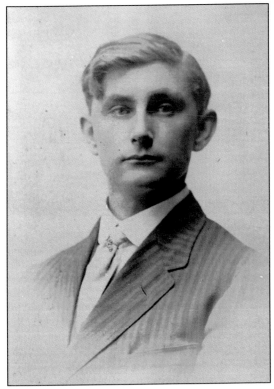

JAMES G. DONOVAN. Shown at age 21,
Donovan grew up in Indiana, graduating
from law school in 1908. He opened his
practice in Houston Heights in 1909.
He moved his family into 730 Cortlandt
Street and in 1925 had a house built at
1225 Boulevard. Donovan is responsible
for the Heights being "dry." His careful
wording of the provision, ending with
the words "till time runneth not,"
has never been overturned. Donovan
Park is named for this Heights leader.
(Courtesy of Gayle Perry Saunders.)

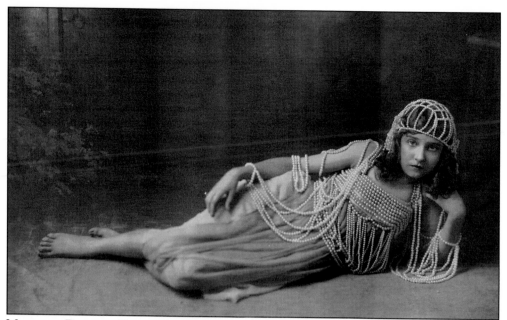

MARCELLA DONOVAN PERRY. The Donovan's only child, Marcella graduated from Heights High in 1922, went to New York, auditioned, and was accepted as a specialty dancer starring with the Greenwich Village Follies, as shown above. Her mother had to sign the contract because Marcella was underage. Later she opened a dance studio above Mading's Drugs at Nineteenth Avenue and Ashland Street. (Courtesy of Gayle Perry Saunders.)

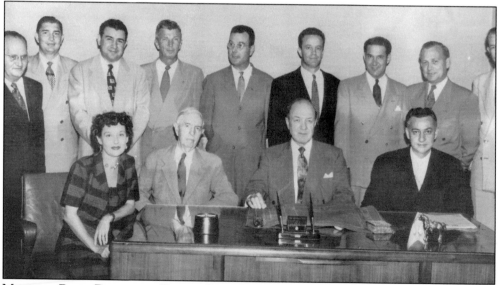

MARCELLA PERRY, DIRECTOR OF REAGAN STATE BANK. Her father, James, was her mentor, and he did not like her dancing career. With his help, she transformed herself into a respected businesswoman. Marcella served on the first board of directors of Reagan State Bank (1950). For the next 35 years, she continued in the forefront of Houston business. She recorded 3-minute spots on radio and television called "Econocasts." She was the first woman appointed as port commissioner, chairman of the Board of Regents for Texas Women's University, chairman of the Parks Board, and a founder of HHA among other distinctions. (Courtesy of Gayle Perry Saunders.)

"PEANUT" BROWN. On the corner of Nineteenth Avenue and Ashland Street was a popcorn and peanut vendor named Edward Brown. Crippled by paralysis, "Peanut" Brown, as he was called, sat with his vending wagon on the street from noon until after dark. Positioning himself at the streetcar stop, he did a good business with passengers getting off the car. His father, Rev. H. J. Brown, did not approve. (Courtesy of Marjorie Griffiths.)

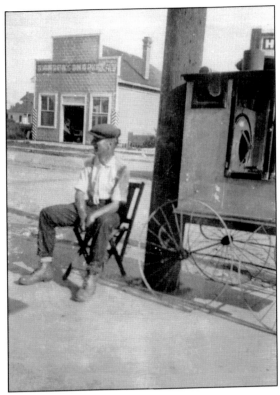

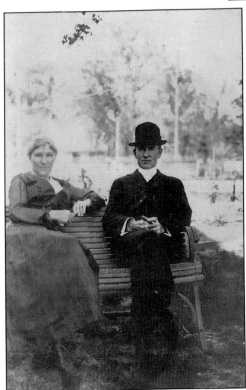

THE PARSONS. Edward E. Parsons and his wife, Martha, are enjoying a nice day in Houston Heights around 1908. Typical of the middle-class residents who settled in Houston Heights, Edward Parsons was an accountant for the Texas Company. They lived in a cottage at 1325 Cortlandt Street and were members of St. Andrew's Episcopal Mission. (Courtesy of St. Andrew's Church.)

GEORGE BURNETT JR. This man of many talents was born at 219 West Eleventh Avenue in 1907 and lived there intermittently all his life. A 1925 Heights High graduate, he went to Chicago Accordion School, where he graduated and became a vaudeville accordionist. Working in a Chicago speakeasy, he met Al Capone, who wanted to hire him. He worked as a "speed" landscape painter in Marshall Field's store window and "rode" the rails to Iowa with Boxcar Myrtle, who was president of the National Hobo Association. He built a popcorn and snow cone trailer and traveled with carnivals across the country. At some time, he also became an expert carpenter and was employed at Ellington Air Force Base as chief cabinetmaker for 20 years. He invented wooden puzzles for which a descendant of his still holds the patents. Irene Ryan (Grannie on *Beverly Hillbillies*) was the love of his life, and though they never married, he continued to spend his summers in Hollywood staying with her. This remarkable man died at his home in 2003. (Courtesy of Arlen Ferguson.)

REAGAN MASONIC LODGE. In 1910, James F. Helms brought the charter for Reagan Lodge No. 1037 from Waco to Houston Heights. The first meeting was held in the recently vacated volunteer fire department hall next to Dr. Olive's pharmacy. In 1916, they purchased a house at East Eleventh Avenue and Harvard Street and met there for 14 years. Before constructing the building above, they had the house moved a few blocks north. On December 31, 1930, their 19,000-square-foot building that cost $110,700 opened. Designed by Lamar Cato, the building had three floors and a basement with a club room and a two-lane bowling alley. The members became nervous during the Depression and sold the building about 1934. It has been converted into condominiums. (Courtesy of Reagan Masonic Lodge No. 1037 AF&AM.)

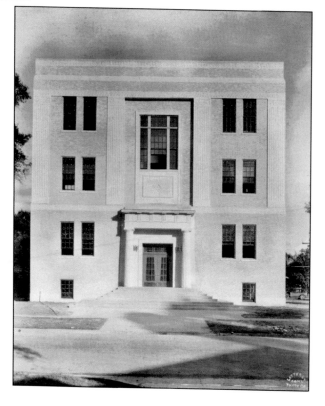

RALPH COOLEY. On Armistice Day 1922, Dr. Ralph C. Cooley poses with his sons Ralph Jr. and Denton Arthur. Ralph's first dentist practice was in the attic apartment of his parents' home at 1802 Boulevard. Denton Cooley, pictured here standing on the right at age 2, is the world-renowned heart surgeon. (Courtesy of Talbot Cooley.)

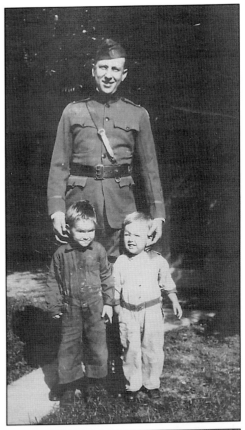

SEA SCOUTS. Troop 24 is pictured in their Sea Scout uniforms. This 1920 photograph shows Clayton Lee with the American flag. The troop had a boat that was, of course, named the *Jolly Roger.* (Courtesy of Libby Lee.)

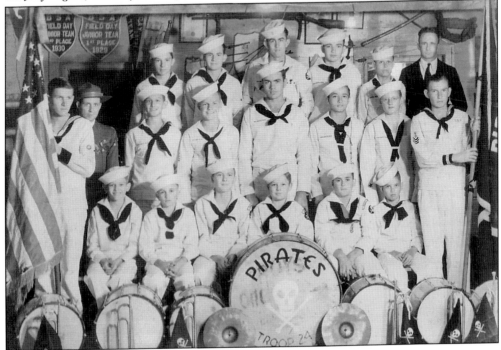

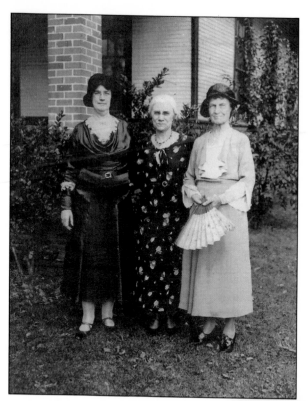

Mrs. C. A. McKinney. Kate Bacon McKinney came to Houston Heights in 1892 with her husband, one of O. M. Carter's original partners. The McKinneys lived at 1630 Boulevard (demolished). As was often the case, her widowed mother and sister lived with them. Kate, an active club woman, served as president of the Houston Heights Woman's Club and president of the Ladies Reading Club. She is pictured in front of the clubhouse with two other past presidents, from left to right: Mrs. W. A. Renn (Della K.), Mrs. J. H. Rose (Roberta), and Mrs. C. A. McKinney. The McKinneys were childless and left the bulk of their estates to DePelchin Faith Home. Helen Milroy was Kate's executor. (HMRC.)

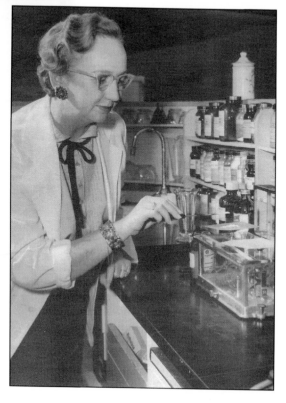

Mildred Grambling Dupuis. One of the first female pharmacists in Texas, she came to Houston Heights in 1923 to open Yale Street Pharmacy with her husband, Abel J. Dupuis. In 1938, Mildred was chosen as the "Outstanding Pharmacist" in the United States. Very active in professional and civic organizations, she, like Kate McKinney, was a past president of the Heights Woman's Club. Their son Joe took over the pharmacy after they retired. (Courtesy of Joe Dupuis.)

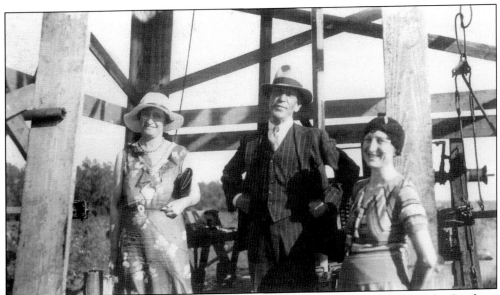

FERDIE TRICHELL. This Heights journalist and entrepreneur was editor/owner of the Southern Pacific Railroad's in-house newspaper for 16 years and founded an orphanage for Houston's newsboys on Washington Avenue. In 1915, she was hired as the Houston Police Department's first female juvenile probation officer. Trichell, who never married, probably lived with the Finfrock family at 415 East Fourteenth Avenue. In 1920, she operated a grocery store at 1526 Yale Street, but by 1922, Trichell (right side of photograph) and her partner Alice Finfrock had formed Tri-Fin Production Company and brought in an oil well. (HMRC.)

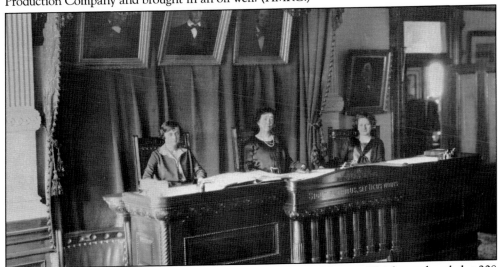

HORTENSE SPARKS MALSCH WARD. In 1903, Hortense came to Houston Heights and settled at 208 West Sixteenth Avenue. In 1909, she married William Ward and completed her legal education. She passed the Texas Bar in 1910, one of the first women in Texas certified to practice law. In 1925, she (above, center) served as chief justice of the Texas Supreme Court to decide a single case involving the Woodmen of the World. The regular justices, Woodmen members, disqualified themselves as members of the organization. The governor had to appoint a female bench. The case, because of its female justices, made national headlines. (Courtesy of Texas State Library and Archives Commission.)

JIMMIE MAE HICKS AND SISTER AGATHA.
These two women devoted their lives to
library work. Miss Hicks worked at the
Heights Library as director from 1931 to
1964. Sister Agatha single-handedly built the
Incarnate Word Library. She bought books
at garage sales and thrift stores that she then
rebound to create a 9,000-volume library.
In 2002, the Texas Library Association
celebrated its centennial and selected Sister
Agatha as one of the 100 Library Champions
in the state of Texas. Hicks asked Sister
Agatha, who lived in Houston Heights until
she entered the convent in 1915, to put
together a scrapbook to preserve the history
of the community. When Sister Agatha
used this scrapbook to write her *History of
Houston Heights 1891–1918*, Hicks was her
assistant. After Hicks's death, the Heights
library had a bronze plaque cast of her image.
Sister Agatha was selected to unveil this
tribute. The importance of this dynamic duo
to Houston Heights' history is immeasurable.
(At left courtesy of Heights Library; below
courtesy of the Dominican Convent.)

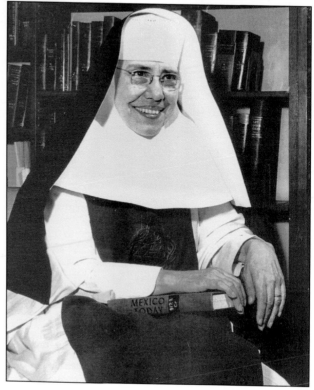

Seven

DIVERSIONS

DEXTER RELAXING AT ROSE LAWN. Pearl Dexter is pictured in the backyard of her home on West Seventeenth, resting on a wooden folding chair and using a parasol to ward off the sun's rays. Note she is carrying a pocketbook on a shoulder strap. That image, her hat, and lovely day dress indicate she must have been on her way to an event. The palm tree grows in the center of a concrete-bordered fish pond. (Courtesy of Fred Whitty.)

Garden Party
at
Rose Lawn
HOUSTON HEIGHTS

MAY
THIRTEENTH
NINETEEN HUNDRED AND NINE

GUEST BOOK

In honor of Miss Mc Kinney.

ROSE LAWN GUEST BOOK. A hand-colored guest book records the lovely party Pearl Dexter held in honor of Ella McKinney, Kate McKinney's sister-in-law, in 1909. Inside the book are the names of who's who in Houston Heights. The booklet was found among Helen Milroy's personal effects. She was a close friend of both Kate and Ella. (HMRC.)

A GARDEN PARTY AT ROSE LAWN. Held at 224 West Seventeenth Avenue, the date on this photograph is 1910. This party must have been very similar to the one honoring McKinney the year before. Obviously, this was another spring affair, as the ladies' long pastel dresses and flowered hats would have been the expected mode of dress. The ladies in dark dresses were probably observing a mourning period. (Courtesy of Fred Whitty.)

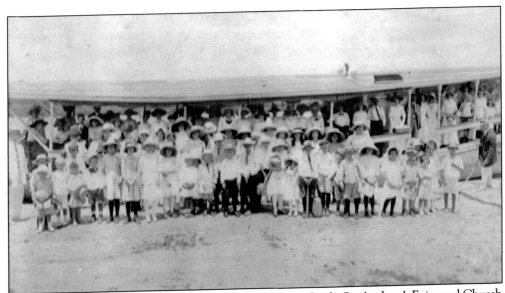

BATTLE GROUND EXCURSION PICNIC. This 1912 photograph of a St. Andrew's Episcopal Church Sunday school picnic is typical of the annual trips made by every Houston and Houston Heights high school, church, and club to the San Jacinto Battlegrounds. A receipt from 1922 signed by Robert Waltrip, acting for the junior class of Heights High, shows rental of the boat *Nicholas and Ethel B.* The excursion boats (there were several) left from the Texas Company Wharf, Harrisburg. The boats departed at 9:00 a.m. and returned at 8:00 p.m. The number of passengers was not to exceed 350, and the total cost was $125. Usually, the picnickers would hire a jazz band or some other music group to entertain them along the way, for this was a two-hour trip. (Courtesy of St. Andrew's Church.)

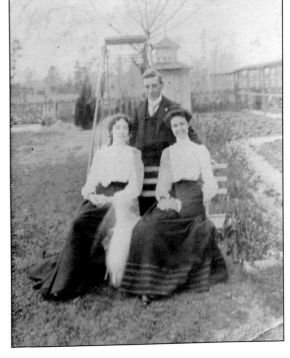

THE DEXTERS IN THEIR GARDEN. Fred and Pearl Dexter are pictured with an unidentified friend (left) as they relax in the garden at Rose Lawn. The two-tiered wooden birdhouse and two-passenger wooden swing pictured at the garden party on the preceding page are in the background. (Courtesy of Fred Whitty.)

SUMMER HOUSE AT ROSE LAWN. This view of the expansive Rose Lawn estate provides a look at the handmade bamboo gazebo with its conical roof. Playing underneath the Victorian wicker pram is Dorothy Dexter. (Courtesy of Fred Whitty.)

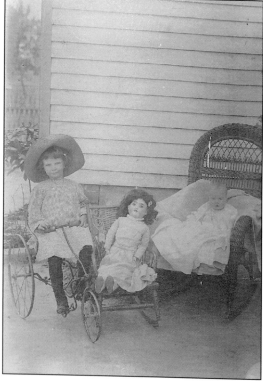

HELIOTROPE BAMMEL. Born in 1910 at 301 East Fourteenth Avenue, Heliotrope is barely able to sit upright as she nestles in this comforter on a wicker rocker. Her older sister Blanche is riding her tricycle, and her doll is in the miniature wicker rocker. (Courtesy of Upchurch family.)

A CHRISTMAS PARTY AT ROSE LAWN. The young wide-eyed guests are posed in front of the Christmas tree on December 25, 1906, and the guest list was as follows: Robert Hartley, Agnes Swift, Hamilton Love, Elizabeth Tempest, Leunice Horne, Ura Hart, Dorothy Gray Dexter, Nelson Duller, Bedelia Pickens, Benjamin Tempest, and Tyler Duller. (Courtesy of Fred Whitty.)

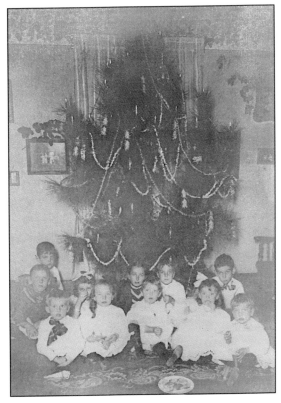

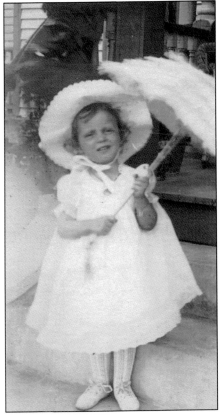

DOROTHY GRAY DEXTER. This beloved daughter of Fred and Pearl Dexter is on the front steps of her home. Her costume, an elaborate ensemble complete with tucked organza eyelet-bordered dress, eyelet bonnet, parasol, white silk hose, and soft white leather shoes, was probably sold as a set. (Courtesy of Fred Whitty.)

HELEN MILROY. Standing near the steps of the side entrance to the Milroy home is Helen Milroy, the spinster daughter of John Milroy. She lived in this house until she died. She is dressed in a "morning tailored gown." Her fur scarf, which was called a "practical neckpiece," her hat, and gloves all denote a lady of means on her way to an important engagement. The hemline dates the photograph to 1912–1914. (HHA.)

MILROY HOUSE SLUMBER PARTY. The third-floor attic bedroom of the Milroy home located at 1102 Boulevard was the setting for this *c.* 1914 sleepover. The four party girls are lounging on a single iron bed. Note two are wearing night caps, and all are enjoying some sort of hot beverage. A large suitcase is stored under the bed. Their hostess, Helen Milroy, snapped the photograph. (HHA.)

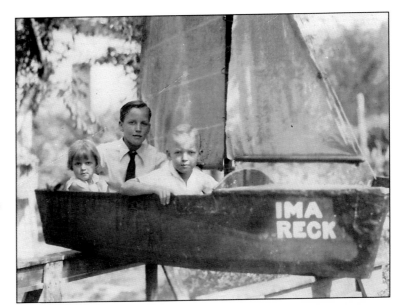

IMA RECK. William Pielop Jr., at 615 West Nineteenth Avenue, built this sailboat and many other boats. He poses proudly for the camera with Dorothy Jane Waldrep and H. O. "Buddy" Quebe Jr. Pielop would later graduate from Texas A&M and establish National Flame and Forge with his father, William Pielop Sr. (Courtesy of Bill Pielop.)

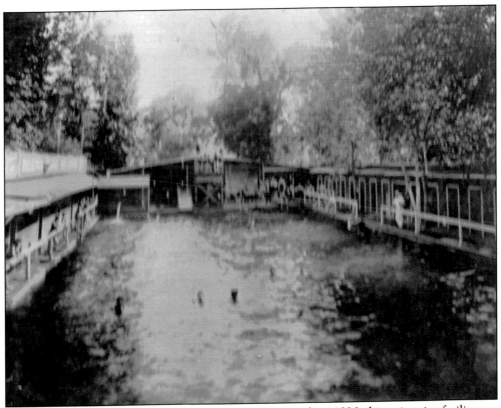

THE HEIGHTS NATATORIUM. A Heights institution dating from 1896, this swimming facility was located at Third Avenue and Harvard Street. The original building burned, and this smaller structure was built. In 1908, they advertised as the "finest equipped Natatorium in Texas." Everyone in the Heights swam at the "Nat." (HHA.)

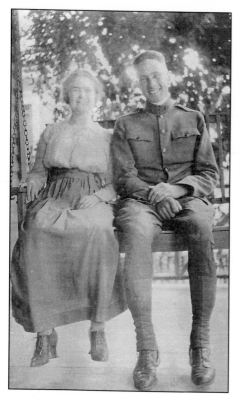

The Porch Swing. At left, Hattie Freet and her future son-in-law Jerry Scales, home on leave from World War I, are enjoying the porch swing at 1305 Yale Street. Cleo Freet, Jerry's charming fiancée, is pictured below on the same porch swing. Real swings were standard equipment for Heights porches. They hung from big hooks screwed into wooden porch ceilings, often painted blue to deter the pesky dirt daubers from their mud nests. These swings offered residents a shaded place to sit in the evening as they waited for the Gulf breeze to come inland. A person could greet neighbors, talk about the days' happenings, or read the daily newspaper, as pictured above. Manual arts teacher Edwin Wyatt built a swing for Dr. Sinclair's porch at 318 West Eighteenth so he would have a place to court his future bride, Alma Louise Pyles, who was Sinclair's sister-in-law. (Both HHA.)

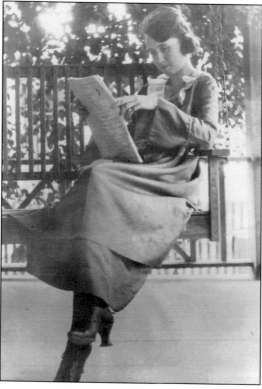

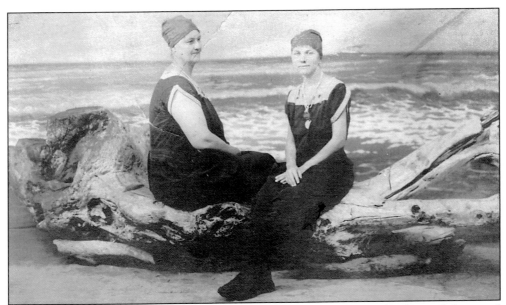

A GALVESTON BATHING SCENE. Irene Upchurch is posing for this studio shot with her good friend Myrtle Barr Oberholtzer in their bathing costumes on a day trip to Galveston around 1917. Oberholtzer, an active Houston club woman, married E. E. Oberholtzer in 1899. Her husband went on to become Dr. Oberholtzer, superintendent of Houston Independent School District (H.I.S.D.) and later president of the University of Houston. (Courtesy of Upchurch family.)

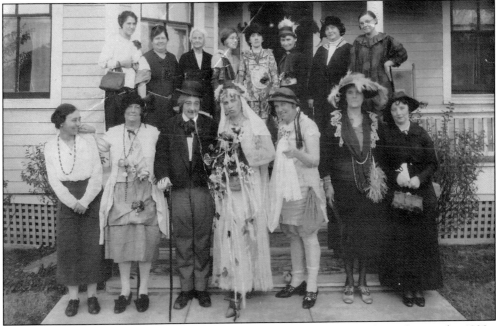

A FALSE WEDDING. Some Houston Heights women are entertaining themselves in the 1920s. An unidentified woman is dressed as the Charlie Chaplin groom, Mrs. Katherine Blocher is the flower "girl" who is holding the unidentified bride's train, Agnes Doyle is on the first row, far left, and Minnie Blazek is pictured third from the right on the back row. The hostess was music teacher Ada Reeves, of 932 Allston. (Courtesy of Hugh Blazek.)

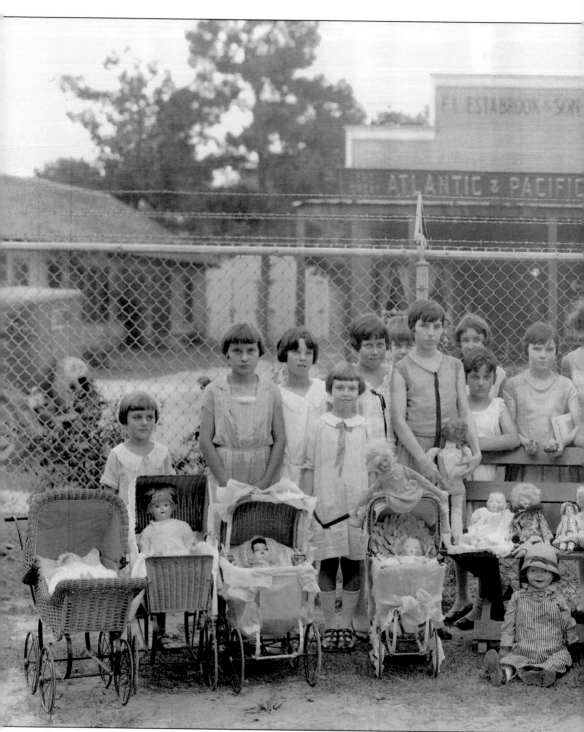

DOLL SHOW. In 1928, this event was held in Milroy Park. The unidentified young girls are lined up with their dolls, which represent a cross section of popular toys at that time. Several have brought their Bye-lo babies. These dolls took the country by storm in the 1920s. Made by numerous manufacturers in the United States and Germany, the original Bye-lo was modeled

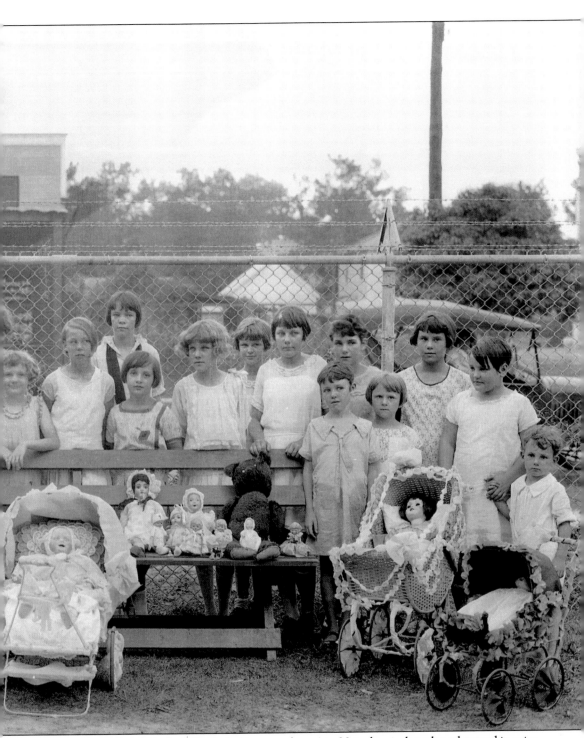

from a three-day-old infant. Bye-lo babies were from 4 to 20 inches in length and ranged in price from 50¢ to $25. The doll wearing the black and white striped costume was a "character" doll. Made primarily in Germany from 1908 until the beginning of World War I, these were modeled after real children and were often life-sized. (Courtesy of Story Sloane.)

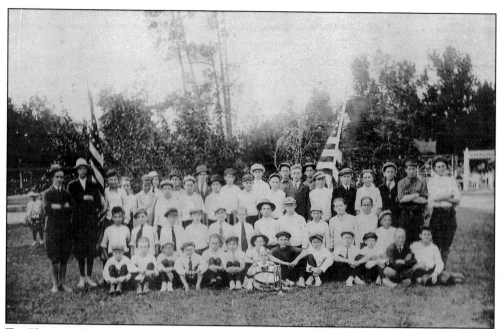

THE HOUSTON HEIGHTS PLAYGROUND. Until the construction of Heights High in 1920 at Twentieth Avenue and Boulevard, this was the site allocated by O. M. Carter to be a park. (Courtesy of Robert Sanders.)

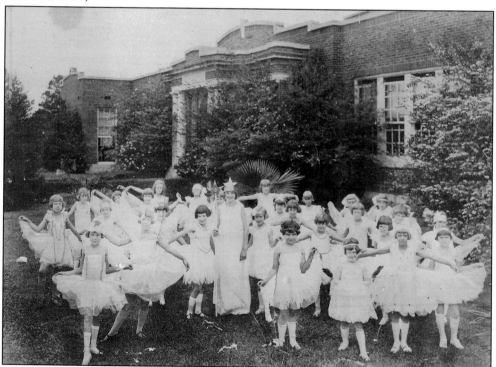

DANCE RECITAL. This 1926 dance recital was held on the front lawn of James Helms Elementary School. The unidentified dancers wearing their lovely costumes are pictured with their unidentified instructor. (HHA.)

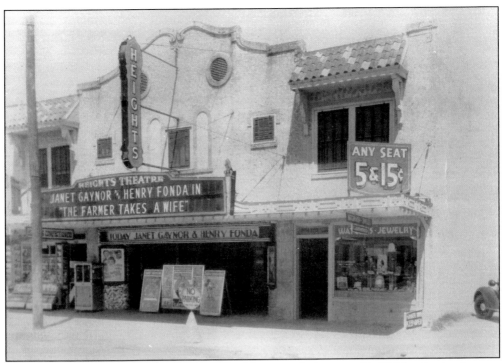

THE HEIGHTS THEATRE. Located at 345 West Nineteenth Avenue, this Heights institution was built in 1929 and provided neighborhood youngsters with a Saturday morning activity: 25¢ paid for the movie and all the popcorn and candy you wanted at the confectionery to the left of the theater. To the right was the well-known Kronberger's Jewelry Store. Kronberger employees and customers had to use the restroom in the theater. The movie announced on the marquee debuted in 1935. (Courtesy of A. B. Kleb.)

TEXAS CENTENNIAL CELEBRATION. Harvard Elementary students are dressed in western clothes for this 1936 photograph commemorating the event that was a yearlong statewide celebration. The older female student is wearing the lone star of Texas as her headpiece, with a red and blue drape over a white gown to represent the state flag. (HHA.)

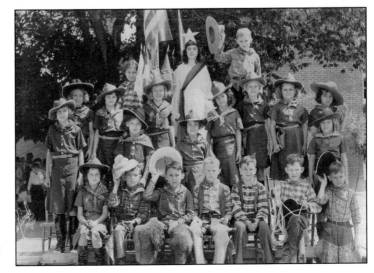

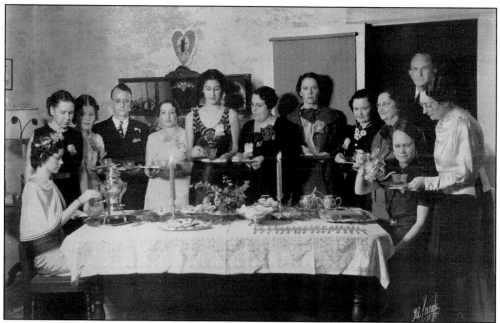

Valentine's Tea. The home at 1817 Boulevard was the setting for this formal event. Brother Jester is probably the man pictured on the right, and his wife, Mae, is standing in front of him. Each of the guests is wearing her Valentine corsage, and the formal table setting indicates that this was a lovely social affair. (Courtesy of St. Andrew's Church.)

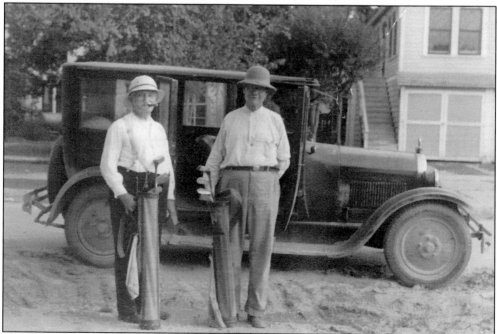

Swilley Golf Game. William Samuel Swilley is pictured on the left with an unidentified golf partner in the 1920s or 1930s. He is behind his home at 1101 Boulevard. The automobile's open doors indicate they have just unloaded or are getting ready to depart for the golf course. By 1925, Houston had several golf courses. (Courtesy of Swilley family.)

Eight

AROUND TOWN

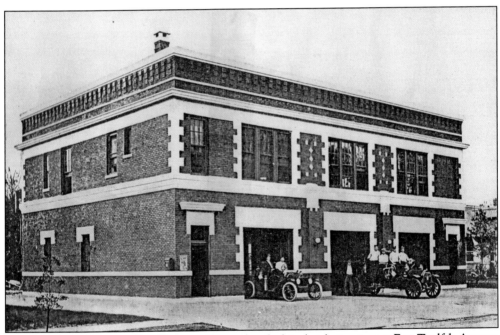

THE HOUSTON HEIGHTS FIRE STATION. The red and white brick structure at East Twelfth Avenue and Yale Street was built in 1914 to be a jail, city hall, and fire station. The cornerstone is the only marker left today of the municipality of Houston Heights. One thousand people came for the opening. The newspaper account said that many had "motored" out from the city and that everything looked quite "metropolitan." Now this building is leased by HHA from the City of Houston and is used for association meetings and events. (HHA; NR, LM.)

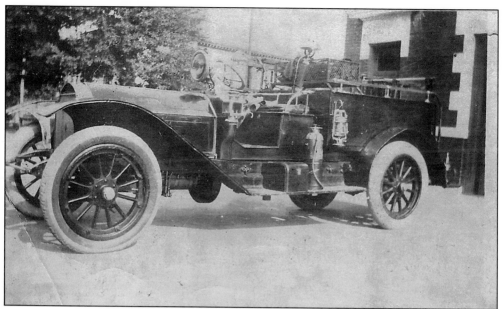

FIRE TRUCK. An early fire truck is parked in front of the station at East Twelfth Avenue and Yale Street. Vehicles like the one pictured were used in Houston as early as 1910, but this photograph is not dated. (HHA.)

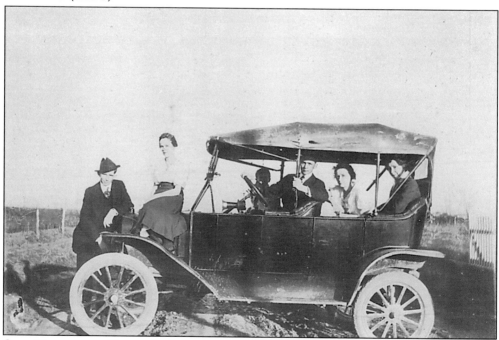

CHIEF DURHAM AND FAMILY. Jay L. Durham, hired in 1910, was the first paid fire chief in Houston Heights and had a three-member crew. After annexation in 1918, Durham was apparently out of a job. The City Directory in 1919 lists Durham as proprietor of an establishment named Automobile Oils and Filling Station, 1247 Boulevard; owner of a grocery and ice cream store at 102 East Thirteenth Avenue; and owner of a Notary Public office next door at 100 West Thirteenth Avenue. Possibly he was renting an office in the former fire station. (Courtesy of Dean Swanson.)

Dr. Sinclair and Family. Sitting on the steps of their first home at 318 West Eighteenth Avenue are, from right to left, a young Dr. Thomas Sinclair, holding baby Marjorie, his wife, Daisy, her sister Alma Louise Pyles (who would soon marry Edwin Wyatt), and grandmother Pyles. Sinclair's doctor shingle indicates that though he had an office on Nineteenth Avenue, he saw patients at home after hours. (Courtesy of Betty Wyatt Henriksen.)

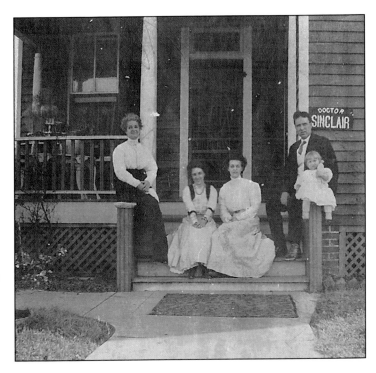

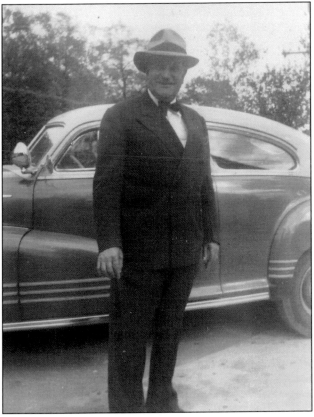

Dr. Mylie Durham Sr. No relation to Jay Durham, Mylie came to Houston in 1919 for his internship at St. Joseph Hospital. He started his practice at Hart's Drug Store at Nineteenth Avenue and Ashland Street and cofounded Heights Hospital with Dr. Sinclair in 1924. Durham and his family lived at 436 West Twenty-first Avenue. He practiced medicine for 45 years and served as the team physician for Heights High and later Reagan High School. In 1962, Durham Drive and Durham Elementary School were both named after this dedicated physician. Two of his sons, Mylie Jr. and Charles, became physicians and also practiced in the Heights. (Courtesy of Pat Durham.)

FIRST LIBRARY AT EAST TWENTIETH AVENUE. This temporary building was erected by the Houston Public Library and opened in March 1921. The small cottage, which had 1,000 volumes, served as the Heights Library for four years. Note Heights High School is to the left. (HMRC.)

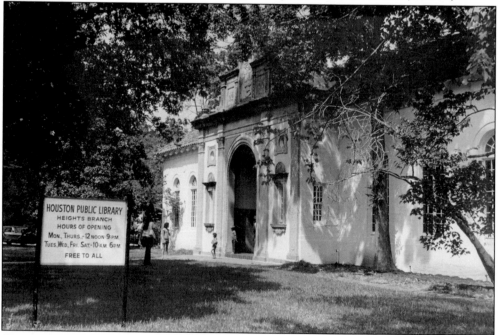

HEIGHTS LIBRARY. The present facility located at 1302 Boulevard opened on March 18, 1926. The Italian Renaissance Revival–style building, originally painted pale pink, quickly became a focal point of the community. Six hundred seventy-four books were circulated the first day. (Courtesy of Heights Library.)

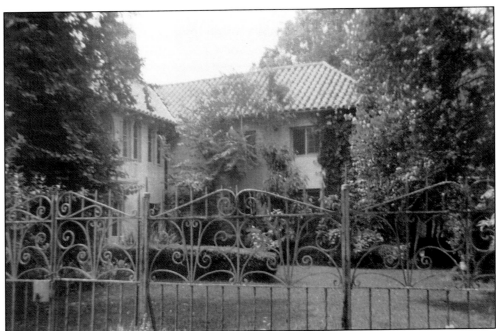

LIBRARY READING GARDEN. In 1939, the Houston Heights Woman's Club created this garden at the rear of the building. To pay tribute to O. M. Carter, they had Victorian veranda railings from his demolished home attached to the latticework in the north corner of the garden. Thomas B. Lewis, a Heights resident, donated a fountain in memory of his son Sam Houston Lewis. Neighbors contributed plants and shrubs from their own gardens. The Heights Theatre staged a benefit to raise money for the garden's new furniture. A local newspaper said, "The garden stands as a monument to the civic cooperation of scores of Heights residents. This garden, along with the south wing pictured above, was demolished to make room for a 1977 inappropriately designed expansion on the southeast corner of the historic building. (Courtesy of Heights Library.)

THE ORCHARD. O. M. Carter had advertised Houston Heights as a home community nestled in a virgin forest, country living in the city. Most homesites were 50 by 131 feet, and many of the backyards had chicken houses, vegetable gardens, and sometimes a milk cow. If extra lots were purchased, fruit orchards like the one above were not uncommon. (HHA.)

MRS. UPCHURCH WASHING AN OPOSSUM. At 301 West Fourteenth Avenue, Mrs. Robert Hickman Upchurch (Fannie) is bathing her pet opossum. In the first photograph, she has the opossum by its feet. In the bottom photograph, the possum is clean and sunning himself on the chicken coop. Presumably, her philosophy was that if you were going to have a pet opossum roaming around your backyard, it should be kept clean. (Both courtesy of Upchurch family.)

WILLIAM WIGGINS'S DOG CART. Wiggins is standing beside the wagon he built. He lived with his family at 1409 Arlington Street, where his father, William R. Sr., operated a garage behind the house. Wiggins has harnessed the wagon to the family's dog. Baby William Pielop is seated, precariously, in the apple crate wagon bed. The baby's older sister Ernestine is standing behind him. (Courtesy of Bill Pielop.)

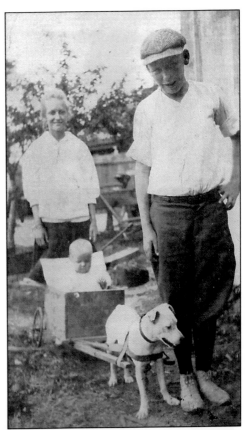

WOLCOTT DAUGHTERS ON EASTER SUNDAY, 1956. Pictured in front of their home at 936 Arlington Street are, from left to right, Darla, Joyce, and Doris. The girls are wearing identical puff-sleeved dresses. Mr. Donald Wolcott operated his plumbing shop out of the garage behind the house. (Courtesy of Wolcott family.)

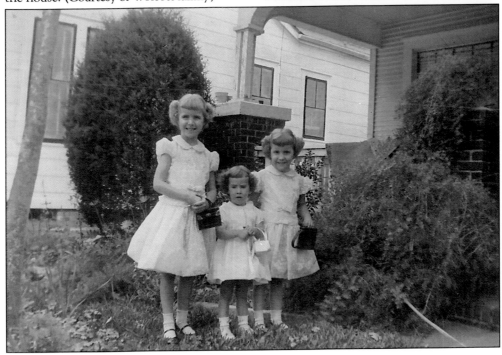

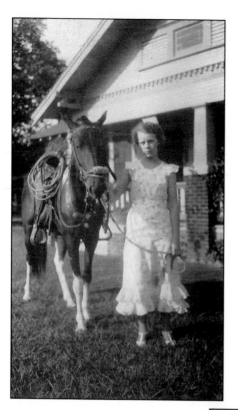

A City Horse. Tex, so named because she was born in 1930 on Texas Independence Day, was kept at a vacant lot on West Twenty-eighth Avenue and Yale Street. The horse is pictured at the Beinhorn family home at 2625 Yale Street. Supposedly, Tex did not like women, but Elma Beinhorn Pielop holding the bridle does not seem afraid. (Courtesy of Bill Pielop.)

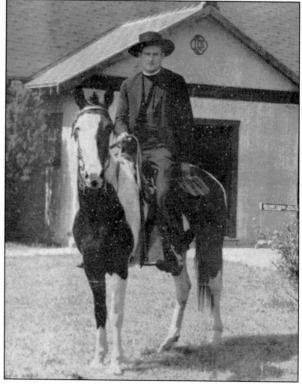

Fr. Jim Airey on Horse. The minister of St. Andrew's Episcopal Church is posing in front of the church with the horse given him by the Sam Houston Whittler's Club for his work as their chaplain. Known as "Cowboy" Airey, he was an honorary chief of the Coushatta Indians and built a Quonset hut to house Western artifacts next to the rectory on Yale Street. The hat, boots, and clerical collar were part of his regular attire. (Courtesy of Marjorie Griffiths.)

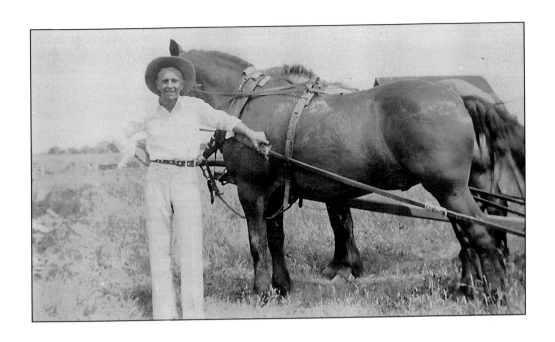

DRIVING AROUND TOWN. In the above photograph, George Polk Sr. is in the 1300 block of Nicholson Street. Polk bought and sold horses and livestock, in addition to running his meat packing business, the Polk Packing Company, located at 1331 Nicholson Street. The roof of the barn is visible at the top of the photograph. In the photograph below, George's brother Jack Polk is behind the wheel of his automobile. They are parked at the edge of the Heights "Cliffs," located on White Oak Bayou at the end of West Seventeenth Avenue. This location was one of several swimming holes on the bayou popular with the young boys in the neighborhood. (Both courtesy of George Polk Jr.)

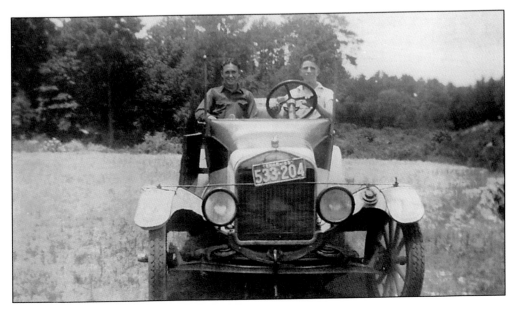

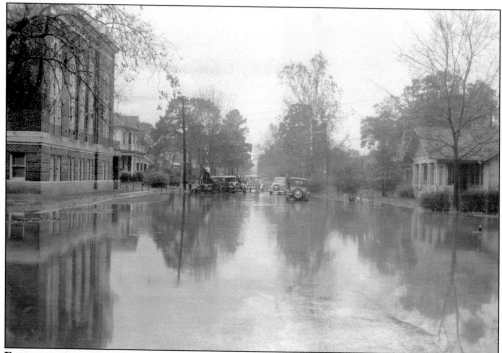

FLOODWATERS IN THE HEIGHTS. The back side of the Church of Christ is shown looking north on Harvard Street at Sixteenth Avenue during the flood of 1945. (Courtesy of Story Sloane.)

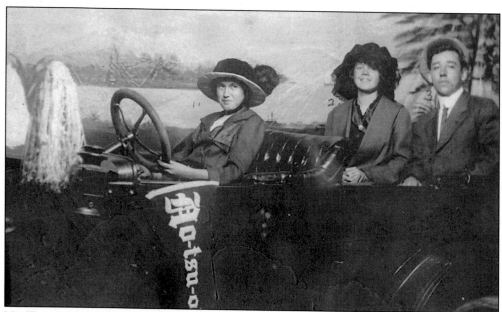

NO TSU OH. Cleo (left) and Thelma Freet are with an unidentified gentleman in this *c.* 1915 studio photograph. No Tsu Oh (Houston spelled backwards) Deep Water Jubilee was the city's biggest social event from 1912 to 1915. King Nottoc (cotton) and Queen Retwa (water) reigned over the festivities. (HHA.)

FRANK WISNOSKI. Born in Poland, Frank came to Houston and started work for the Houston City Street Railway mule-driven streetcar system in 1890. When Carter bought both companies and electrified them, Wisnoski stayed on, becoming a familiar face to Heights passengers. He retired after 43 years, but when the end of the streetcar system came on June 9, 1940, Wisnoski was in the Park Place car that made the final run. (HHA.)

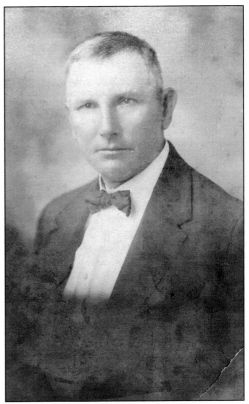

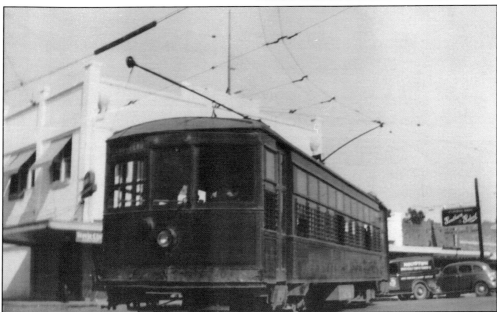

HEIGHTS STREETCAR. When completed, the Heights line was the longest in Houston. This line was always one of Houston's most frequented, and in 1923, the Heights–South End route was also the most profitable. The streetcar pictured is just passing Ward's Drugstore at the corner of Nineteenth Avenue and Ashland Street. (Courtesy of Randy Pace, Neil Sackheim-Carter, and Cooley Deli.)

Discover Thousands of Local History Books
Featuring Millions of Vintage Images

Arcadia Publishing, the leading local history publisher in the United States, is committed to making history accessible and meaningful through publishing books that celebrate and preserve the heritage of America's people and places.

Find more books like this at
www.arcadiapublishing.com

Search for your hometown history, your old stomping grounds, and even your favorite sports team.

Consistent with our mission to preserve history on a local level, this book was printed in South Carolina on American-made paper and manufactured entirely in the United States. Products carrying the accredited Forest Stewardship Council (FSC) label are printed on 100 percent FSC-certified paper.

MADE IN THE USA